IMAGES
of America

BELLEVILLE
1814–1914

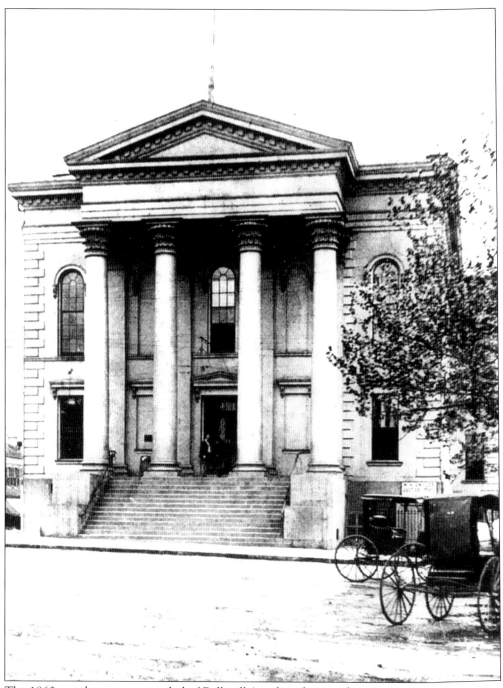

The 1860 courthouse was a symbol of Belleville's political power for 112 years.

IMAGES
of America
BELLEVILLE
1814–1914

Robert C. Fietsam Jr., Judy Belleville, and Jack Le Chien
Photo Editor Robert L. Arndt

ARCADIA

Published by Arcadia Publishing
Charleston SC, Chicago IL, Portsmouth NH, San Francisco CA

Printed in Great Britain

Library of Congress Catalog Card Number: 2004110909

For all general information contact Arcadia Publishing at:
Telephone 843-853-2070
Fax 843-853-0044
E-mail sales@arcadiapublishing.com
For customer service and orders:
Toll-Free 1-888-313-2665

Visit us on the internet at http://www.arcadiapublishing.com

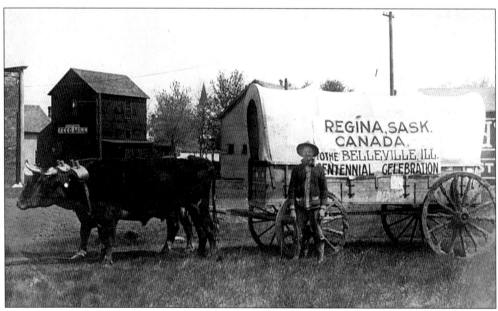

Wandering Charles Wasem, famous "Belleville or bust" promoter of the centennial.

CONTENTS

ACKNOWLEDGMENTS

This project has been a cooperative effort of the St. Clair County Historical Society, Belleville Historic Preservation Commission, and Labor & Industry Museum. Special thanks to Robert L. Arndt, photo editor, for his long hours, skill, and patient demeanor. Photos are identified in the index as belonging to: STCC, St. Clair County Historical Society, 701 East Washington, Belleville, IL 62220, (618) 234-0600; BPL, Belleville Public Library, 121 East Washington, Belleville, IL 62220 (618) 234 0441; Labor & Industry Museum, 123 North Church, Belleville, IL, 62220, (618) 222-9430; the Labor & Industry Museum is also the contact for Belleville Historic Preservation Commission photos. Thanks to Lou Ann James of the library for research assistance, Allan Kent for proofing chapter three, and Gina Raith for proofing chapter one. Also, thanks to Robert Gentsch and Otis Miller, Belleville history professors, for their helpful comments.

Proceeds from royalties will be shared by the St. Clair County Historical Society and the Labor & Industry Museum.

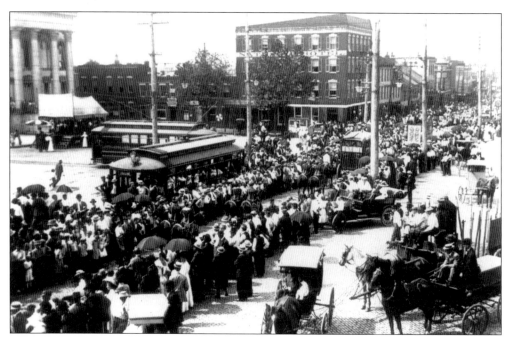

INTRODUCTION

Our approach to presenting the collection of photographs and illustrations herein has been to order the presentation, as much as is possible, in chronological stages. This method allows us to emphasize the historical and cultural perspectives of Belleville's progress from a designated spot in a farmer's field, where virtually no semblance of a town or settlement existed, to that of a thriving and vibrant urban center—a rather phenomenal change taking place within a relatively short span of one hundred years.

Such a story has been told over and over by Belleville residents and others on different occasions and in different eras—we attempt to tell the same story in a lavishly illustrated way. Our presentation is a unique combination that presents perspectives on historical development within a photo-journal format. There are, however, limitations to this approach.

This project has not been designed nor has it been intended to be a definitive historical or complete pictorial account of Belleville's history. The narrative we have developed is inherently limited by an ability to obtain a representative photograph to introduce a particular subject. An interesting photograph might not fit the tread of the narrative being introduced. Also, photographs unavoidably must appear more for their curiosity or artistic value than for their representation of a theme. Ultimately, the photos themselves enrich the historical themes introduced, and vice versa—a photograph is worth a thousand words, or so the cliché goes. And so, it is left up to the reader to complete the narrative.

The chapters we used to organize our presentation were not referenced from any textbook, but rather they are an amalgam of our joint collaboration on how we viewed and interpreted Belleville's development through our research and what the pictures themselves conveyed to us. While there are quite a few volumes written about Belleville, none seem to be a definitive work on early Belleville's first one hundred years. We have chosen somewhat arbitrary timeframes which appeared to have some demarcation to distinguish one period from another. Thus, our chapters are not strictly defined in terms of calendar years, rather they roughly correspond to timeframes distinguished by certain development in Belleville's history. Chapter timeframes start with the establishment of St. Clair County and proceed to roughly the mid- to late 1840s for the Frontier and Formative Years Chapter. Then, from the mid- to late 1840s through the Civil War marks the German Element Chapter. Proceeding from the end of the Civil War to Belleville's centennial celebration in 1914 roughly encompasses the Fifty Years of Industrial Growth Chapter. Next we glimpse Belleville's flamboyant centennial extravaganza in the 1914 Centennial Chapter. We then conclude, offering perspectives on current preservation initiatives.

Our historical narrative has also been divided by the respective author's specialized perspective garnered from his or her affiliations in local historical societies and museums. I,

Robert Fietsam Jr., past president of the St. Clair County Historical Society, present the Frontier and Formative Years Chapter, as Belleville's history is inextricably linked to that of St. Clair County's history by virtue of Belleville becoming the county seat in 1814. Jack Le Chien, past chair of the Belleville Historic Preservation Commission and chair of the committee formed to develop a Gustave Koerner museum and interpretive center, covers a time when Belleville's "German Element" was at the peak of its contribution to Belleville's development and political influence. And for the Fifty Years of Industrial Growth Chapter, Judy Belleville, charter member of the Labor & Industry Musuem Board and now serving as collection coordinator, brings a wealth of knowledge concerning Belleville's commercial and cultural history to our presentation's coverage of Belleville's maturing industrial phase. Jack Le Chien and Judy Belleville's long association with preservation and historic districts adds valuable insights into our Preservation Chapter.

What has emerged, as a product of our joint collaboration, is an interesting and illustrated glimpse of Belleville's first one hundred years. The story of Belleville's evolution is interesting, indeed. Chosen by a special commission charged with finding a new location for the county seat of St. Clair County and dubbed "Belleville" by the person whose land had been donated for that purpose, the planned community of Belleville began in 1814 on the site of a George Blair's isolated farm, in proximity of no major crossroads. In this publication, we chronicle Belleville's early formation and its remarkable—if not phenomenal—rise to a leading Southern Illinois city, a feat celebrated to no small degree by proud residents at the occasion of Belleville's centennial celebration.

Limitations of available space to adequately display Belleville's historical and cultural heritage were such that limiting our presentation to the first one hundred years seemed natural and timely, as Belleville will celebrate its bicentennial in a scant ten years.

This edition, the second of which we anticipate will mark a bicentennial, presents a generous collection of images which lend credence to the citizenry's centennial boasting portrayed in extravagant festivities and in publications of the day. Photographs and other representations from available archives are used to chronicle Belleville's rise to prominence in regional and state politics, as well as successes in agribusiness, mining, banking, industrial, manufacturing, and retail economic sectors. The promotion of Belleville's fortunes by very influential early Illinois state politicians, combined with a robust entrepreneurial spirit and an industrious workforce, eventually transformed Belleville into an important urban center. A large sampling of some of these individuals are represented in this edition, including major Illinois politicians entering the pre-war Civil War debate, some of whom found Belleville an irresistible campaign stop, owning to the personal friends and the political connections they found in Belleville—including none less than Abraham Lincoln.

We venture to say we have compiled an interesting and informative gallery of Belleville's early movers and shakers, industrialists, workers, and immigrant population, which illustrates the rich cultural mosaic that contributed to Belleville's reputation as "Capital of Southern Illinois." Taken as a whole, these images might give one a sense of why modern Belleville residents' pride in their city's history has led to current initiatives to renew preservation efforts, refurbish historical structures, and develop tourist venues to display Belleville's history and heritage.

We hope you will enjoy a perusal through our pictorial study of Belleville's first one hundred years, as much as we did composing it. And, we look forward to the second installment of a bicentennial edition in 2014.

—Robert Fietsam Jr.

One

FRONTIER AND
FORMATIVE YEARS

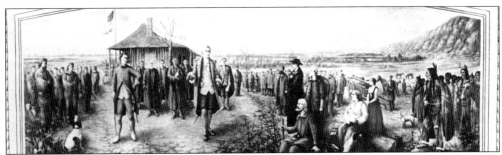

Pomp, ceremony, and old world protocol blend amid a rugged frontier setting, as Gov. Arthur St. Clair is portrayed on the occasion of his formal declaration of the establishment of St. Clair County in 1790. Frontiersmen, clergymen, colonial settlers, Native Americans, and newly-appointed county officials are all on hand to witness the new administrator's assumption of authority over the area. This large, colorful mural is currently on display in the St. Clair County Board room. The artist's depiction of a dog placed prominently in the foreground is perhaps an editorial on the decorum of the event.

The extent to which the county had well-developed governmental institutions and a frontier trading economy by 1803 was used to full advantage by Meriwether Lewis and William Clark during their expedition's five-month preparations base stay in St. Clair County. The explorers received able assistance from St. Clair County officials, including future Belleville resident, John Hay, clerk of the county court and a U.S. territorial postmaster operating out of Cahokia. Hay was invaluable to Lewis and Clark as an interpreter and acting as an advisor concerning frontier travels. Hay, as postmaster, was Meriwether Lewis' direct communication link with the expedition's mentor, President Thomas Jefferson. John Hay became one of the leaders of the county seat relocation efforts in 1814 by taking part in a county selection committee, and one of the first to take up residence in the new village of Belleville, continuing his positions in administrative offices of St. Clair County government.

County officials showed a willingness to abandon the trappings of the old colonial world for a new county seat to be built from scratch. The relocation would follow an emerging demographic trend, leaving river settlements for prairies on the interior and allowing a new, more American melting-pot character to develop for the county seat. But, starting from scratch would be a challenging task for those wishing to build a town in an isolated area of no significant importance and little reason to travel there, until it was decreed to be the county seat. The formative years of the town's existence would show promise, but uneven growth. It would be perhaps 30 or so years after the founding of Belleville before there began to be indications that Belleville was likely destined to develop into a major urban center.

A cornfield—not busy crossroads—marks the location of the new St. Clair County Seat. A special relocation committee was directed to find a new county seat, and in 1814, a spot "marked" near George Blair's 200-acre homestead, "in his cornfield," was officially reported as their choice. Blair apparently sweetened the deal for the undecided commissioners, donating an acre of land for a public square and 25 acres surrounding the square in an every-fifth-lot sequence "for use and benefit of the county." George Blair's strategic donations made him Belleville's first citizen and land baron, allowing him to name the streets, few of which today are still so named. John Hay and his fellow county administrators somehow manged to conduct county business after choosing the remote site, where little in the way of a support structure for governance would be immediately available.

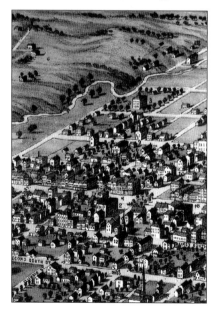

Renowned surveyor John Messinger, at the invitation of George Blair, produced a town plan. His rendering of the "Original Town of Belleville," pictured above, features orderly streets and perfectly square blocks. That basic design survives much later development, and is evident in the 1867 illustration pictured on the left. Messinger's designs for Belleville also include himself, as he will purchase a home in Belleville. Messinger becomes an influential politician in the State of Illinois' very early formation. His surveying in the northern Illinois Territory may have helped extend the state's northern boundary to encompass later-day Chicago. The undulating hills, characteristic of Belleville's terrain, are clearly evident in the 1867 bird's eye view. An 1825 plat map indicates a mill was situated along Richland Creek, the small meandering stream shown on the outskirts of the town. A sawmill was also said to have existed at an early date, which must have facilitated construction in the town.

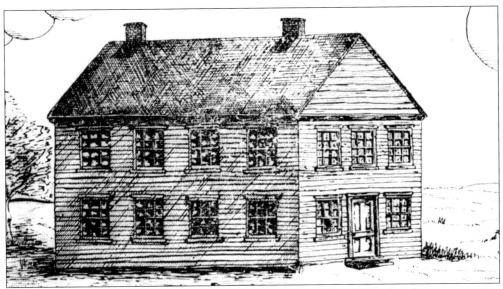

Belleville's first county courthouse was completed by September 1817, though a construction contract had been let in 1814. Court was held temporarily in a small log cabin, possibly George Blair's house. With two stories and a dimension of 30 feet by 24 feet, the new courthouse was described as being quite substantial for its day, given the sparseness of the village. Etienne Pensoneau was paid $1,525 for the courthouse construction, which was financed by the county in part by the sales of some of the lots it had acquired. Blair abandoned his short lived dabbling in land speculation, selling his remaining interest to Pensoneau, who seemed disinclined to the risk-taking necessary to develop the still fledgling frontier town. Pensoneau improved his and Belleville's fortunes by selling the land to a promoter and savvy capitalist with political connections, money, and moxie—Ninian Edwards.

Ninian Edwards had the wealth and the ambition to be Belleville's foremost early promoter. He invested his money and energy in Belleville's commercial fortunes, helping to foster an environment in the village that sets it on a trajectory for later growth in decades to come. Edwards was a very influential politician, serving as Illinois' first and only territorial governor, its third governor, and its first U.S. senator. Edwards moved to Belleville, operated a store, and became a large landholder of the town. Then, he began taking a stake in Belleville's future, selling lots at bargain prices to attract a skilled labor force. Edwards advertised 40 percent discounts on lots as enticements "to accommodate some respectable mechanick [sic] who may be desirous of settling in that village." And, when Thomas Harrison needed land to expand his mill facilities, Edwards sold him the land for a mere dollar—a paltry sum even in that day. Edwards' Belleville career was cut short when he died in Belleville in 1833, a victim of a cholera epidemic.

John Reynolds was another very influential Bellevillian involved in early Illinois state politics, serving as an Illinois supreme court judge and governor of Illinois. He also served as a member of the U.S. Congress. Upon relocation of the county seat, he moved to Belleville and served locally as a judge. Reynolds' business ventures were great boons to Belleville's future industrial and commercial economy. Many of his endeavors improved transportation, which had been a significant drag on Belleville's commercial growth. In 1837, he invested in the first railroad, a mule driven version, running from the Mississippi River bluffs to St. Louis, spanning a 2,000 foot lake, to market his coal. Belleville's abundant seams of coal would be of enormous importance in a region soon to industrialize by harnessing steam power. In 1846, he again did much to improve Belleville's access to markets, as an investor in the first road in Illinois to be composed of oil and rock, which ran from Belleville to St. Louis. Reynolds' ventures did much to set Belleville on a course of industrialization to be realized later in the 19th century.

Samuel Chandler maintained an active business and public career. Chandler co-invested in important commercial enterprises with John Reynolds in the building of the mule railroad. He joined Reynolds in 1847 on the board of the St. Clair Turnpike Co. to build a macadamized road 30 feet wide from the Mississippi River bluffs to High Street in Belleville. Besides being a financier, he also bred cattle. Chandler's public contributions included holding several pubic offices, such as sheriff from 1836 to 1846, helping to spearhead the establishment of a private firefighting company, and becoming a founding member of the Illinois State Agricultural Society. Under his influence, the Agricultural Society adopted a resolution in 1865 "to aid us in the laudable effort to prepare a school for the education of the laboring classes."

Conrad Bornman, originally a blacksmith, abandoned his trade and started anew in the brick industry. The Belleville area had the type of clay deposits that could be readily used to manufacture brick. An ample supply of brick could be produced for periods of increased building activity, which the town would experience by some accounts after 1828. Bornman, who came to Belleville in 1819 at the age of 20, emigrated from Germany and was said to have been one of the first Germans to arrive in Belleville. Bornman became prosperous, with his success confirming the often-repeated adage of the United States being the land of opportunity, especially where few barriers to entry existed for hardworking individuals seizing an opportunity in a new town—like Belleville, which was at that time being built, literally, from the ground up.

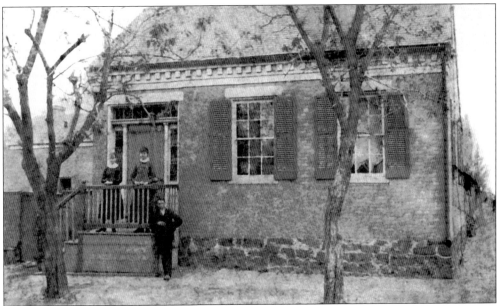

The Bornman home today is the last remaining German Street House in the original town of Belleville platted by John Messinger in 1814. Bornman built his two-and-one-half room house, shown in an early image, in the classical severity of the "Klassizimus" style popular in 1830s Germany. The brick house is one and a half stories, with gabled side walls and a cornice of brickwork across the front. The original entry was a single door with sidelights and a transom. The windows are evenly spaced, and the wood lintels are original to the building. The interior of the house has log lintels with the bark still on them. Years of usage by early occupants of the building is still evident, as the building retains the original worn pine thresholds, stairway, and floors. The street house building has housed a series of businesses into the 20th century and presently houses the collection of the Labor & Industry Museum.

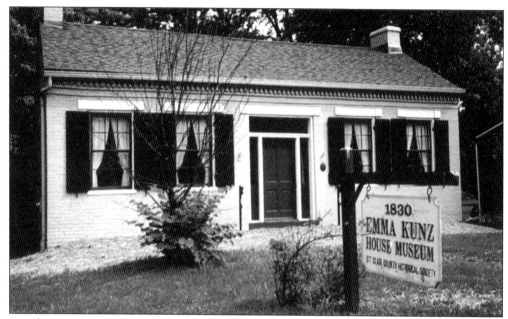

Another surviving structure from Belleville's early days is the St. Clair County Historical Society's Emma Kunz House pioneer home. It was built in the European, Greek-revival style popular in the early 19th century. Its appearance in early Belleville possibly makes it the oldest structure of its type in the State of Illinois. Gustave Koerner, a prominent mid-1800s Belleville politician, purchased the home as a wedding gift for his daughter. The St. Clair County Historical Society has refurbished the house and moved it to its present location to avoid demolition. The society offers tours of the house, which is fully furnished in the décor of the age with what few comforts and labor-saving devices were available to pioneer settlers

Daniel Murray, was elected president of the first Board of Trustees of Belleville in 1819. Belleville can scarcely be called more than a small village or hamlet at this time. Murray, originally from Baltimore, settled with his large family in Belleville in 1817 and became a leading and respected member of the settlement. Murray served only one year as president. The village in 1820 was estimated to have had only 20 to 25 families calling Belleville their home. Early arrivals to Belleville, before the arrival of German immigration in the 1830s and 1840s, were predominately from Kentucky, Virginia, and New England. By 1845, Belleville's population had grown to about 2,000. By 1850, Belleville would achieve city status, at this time there were about 4,000 inhabitants.

Benjamin Hillary West Sr., born in Virginia in 1817, traveled with his family to St. Clair County in 1818. He married Catherine Hill in 1841 and lived in this stately home on his farm, one mile south of Belleville, for 60 years. Other members of the extended West family are associated with real estate investment downtown and in the east Belleville neighborhood of Oakland. West Boulevard in the vicinity of Belleville's eastern boundary is connected to the family name. The West family also had other land holdings immediately south of Belleville, where this farmhouse was located before it was razed in the 20th century.

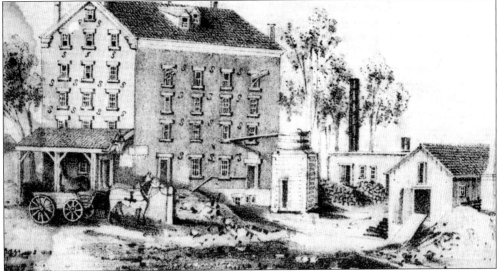

Milling of grain was one of Belleville's first successful enterprises, a natural expectation for a town virtually sprouting out of a cornfield, as it were, and surrounded by abundant acres of fertile land under cultivation. Even before Belleville's farmland location had been condensed, the 1810 Wilkinson and Ringgold Flour Ox Mill, located in the near vicinity, had became the second mill built in Illinois. Its successor, Harrison Mills, pictured above, encompassed a 14-acre tract located on the east bank of Richland Creek and also used teams of oxen as its motive power for a time. Early production was limited to a few hundred sacks, mainly due to poor road conditions and an inability to tap other markets. By 1835, the Harrison & Co. mill became the first steam-powered, large production mill in Southern Illinois, eventually shipping its product to markets in adjoining counties in Illinois and Missouri.

A large number of German immigrants appeared in the region in the 1830s and 1840s, settling in and around Belleville, some of whom became refugees after failed movements for democratic reform had caused great turmoil in Germany. Many came from professional backgrounds in their native land, which were sometimes abandoned due to a language barrier. A fair number settled in the Shiloh Valley, slightly east of Belleville, acquiring the name of "Latin Farmers." As a group, they were fairly affluent and highly educated prior to their arrival in the United States. Some tried their hand at farming, but showed more talent for reading Latin than for using a plow, motivating some to return to their professions in the towns, including Belleville. They seemed determined to bring some of the old world culture with them and introduce it to their backwoods abodes. Wishing to advance literacy in their frontier community, the Latin Farmer group formed a library, electing Dr. Anton Schott as their first librarian. Citizenship papers and personal effects displayed above are those of Dr. Schott.

Theodore Hilgard Sr. came to America in 1834 and led efforts to establish the independent community of West Belleville, offering to sell 230 residential lots at $50–75 per lot. Hilgard was well-educated and held high level government posts in Germany. He encouraged his family members to also emigrate. He himself was given a great deal of encouragement to emigrate from the Marquis De Lafayette, of American Revolution fame. In a letter to Hilgard, Counselor of the Royal Court of Zweibrucken, Layfayette congratulated Hilgard on his "affinity with the great and excellent land of liberty," and offered his letter to help with Hilgard's "acceptability in the different parts of the Union where you may find yourself." Hilgard found himself in Belleville— probably finding the lofty letter of introduction unnecessary—operating a lumberyard in 1841. Hilgard returned to Germany in 1854, but many of his family members stayed in Belleville.

Theodore Engelmann and his life-long friend, Gustave Koerner, became refugees as the result of their participation in a failed political uprising aimed at installing democratic reforms. Both were spirited out of Germany in 1833 with Engelmann's family, arriving in America that same year and eventually settling in the Shiloh valley. The Frederic Engelmann Family Shiloh homestead became a gathering place for the Latin Farmer group. Although Theodore Engelmann did not share the typical Latin Farmer's poor grasp of farming, he was drawn back to urban life in Belleville as a lawyer. In 1842–1843 he held the position of clerk of the Town of Belleville. His leading contribution to the German-American community is his promotion and editorial input to two Belleville German-language newspapers that served the needs of German immigrants and, most importantly, facilitated Gustave Koerner's lines of communication with the German-American electorate, which Koerner lead for his Republican Party political ally, Abraham Lincoln.

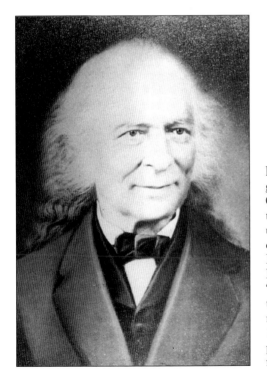

Like a number of others of the Latin Farmer group, George Bunsen was also forced to flee Germany as a result of his association with the 1833 "Burchenshaft" student fraternity uprising. Bunsen was an inventor and educator before coming to Belleville in 1833. He served on the first State Board of Education in 1856, promoted the first "Normal School" for state teachers, conducted testing of Belleville teachers, and was a member of the Belleville School Board from 1859 to 1872. Bunsen dedicated his life to the principal that an educated public is essential for a successful democracy.

17

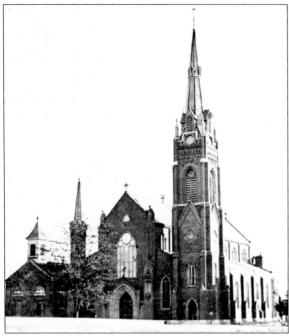

The Belleville area was considered a Catholic Mission until Rev. Joseph Kuenster was appointed the first resident pastor in 1842. He gathered his parishioners together to build a church. On Christmas morning in 1843, mass was celebrated, but the church was unfinished. The parish grew and purchased a portion of Walnut Hill for a cemetery in 1850. In 1857, a convent was built for female education and in 1860 St. Vincent's Orphan Society was established. The cornerstone for the second St. Peter Church was laid in 1863 and a dedication was held in 1866—the two spires came later. The second church became a Cathedral in 1887 when a diocese was created with headquarters at Belleville.

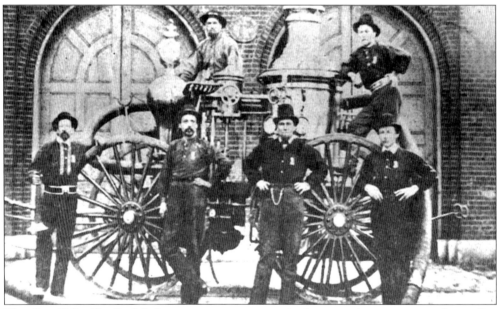

The first Belleville firefighting company was organized as a private venture. An earlier newspaper editorial, written in the late 1830s, had asked for a remedy for making fire equipment available with such items as hooks, ladders, and fire buckets. But the editor conceded a fire engine would be too costly at that time. Though only a few years later, by 1841, a number of important individuals lent their support to a private firefighting company. Some of the better known members included: Lyman Trumbull, Gustave Koerner, J.L. Morrison, and Samuel Chandler. There would be no immediate relief for the bucket brigade for several years, however, until Koerner traveled to Baltimore to purchase Belleville's first fire engine. Pictured above is a Belleville fire crew with their horse-drawn fire engine of an early but unknown vintage.

Simon Eimer arrived in Belleville from his native Germany in 1844. Shortly after his arrival, he acquired land immediately to the south of Belleville to start his own private urban planning initiative, creating a park he named, you guessed it—"Eimeresberg." Eimer added to the festive atmosphere of the park by opening a restaurant and dance hall. The park quickly became a popular site for festivities and socializing. Eimer becomes a monopolist of sorts in catering to the demand for recreation and diversions. In 1846, he built a beer brewery near his park and in 1856 he opened another drinking establishment, a saloon at Main and Spring streets, effectively cutting out the middleman. Eimer's Western Brewery develops into a very successful business and Eimer becomes very prosperous.

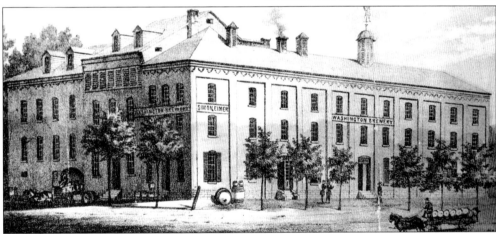

The original Washington Brewery was built by Simon Eimer in 1846, and was located adjacent to his Eimer Park and Vineyard. Apparently, Belleville's beer was said to have been of good quality. Belleville brew was given a glowing endorsement by John Reynolds, who wrote that "the ale and beer of Belleville are known all over the west"—a testimonial of perhaps limited value as wild west pioneers were likely not all that discriminating in their preference of alcoholic beverage in saloons on the dusty trail. It was also said that the Western Brewery was the largest brewery west of the Allegany Mountains. That was also a tall claim, and again perhaps a hard one to substantiate. But, the Western Brewery beer was a popular brand and by 1862 the brewery was the largest of eight Belleville breweries, producing 8,000 barrels annually. Belleville's brewing industry had begun as early as 1829 with the Fleischbein Brewery located on the corner of the public square, apparently proving there were no zoning restrictions on the public square in early Belleville. The brewery complex pictured is the second Eimer brewing enterprise located at the third block of South Second Street.

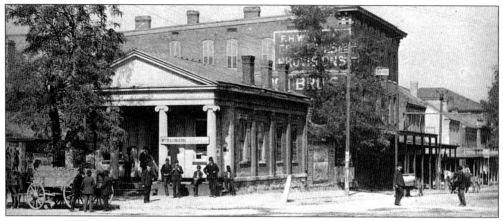

A crowd is seen gathering around what had formerly been the site of the Hinkley House of Banking building on the northwest corner of Belleville's public square. William Baumann, justice of the peace, occupies the building in this photograph taken in 1893. Previously, this ornately-columned building had housed Belleville's earliest banking institutions and their successors in the mid-1800s. Early financiers had to contend with severe business cycle downturns, since no centralized monetary policy was in effect to help stabilize the national economy. According to contemporary accounts, Belleville's very early economy sagged until 1828, when the pace of building and economic activity had improved considerably. Several banking institutions were formed in Belleville in the 19th century, providing capital for expansion and growth.

This 1859 lithograph shows Belleville as a town where a pastoral scene meets in harmony with urban progress. The grazing animal in a rural setting immediately surrounding the thriving town is indicative of the natural advantages of agriculture at the city's doorstep. The horse-drawn railroad car carrying some commodity reflects on early efforts to solve transportation difficulties before the advent of steam railroads and paved roads. By the mid-1840s, Belleville was entering a new phase and was no longer quite the rough pioneer outpost. Belleville's prospects for future growth were now bright. The influx of immigrants was steadily increasing the town's population to about 2,000 by 1845 and it was soon to double in five years. Bellevillians were gaining confidence and pride in their growing town. Belleville's resources of

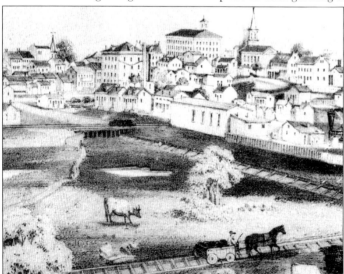

fertile soil, abundant coal deposits, and an increasingly larger and skilled workforce would be used to Belleville's advantage in its emergence as a leading Southern Illinois city in agribusiness, industry, commerce, and culture. Near the end of Belleville's formative years, roads were beginning to radiate from the same place where no crossroads had existed when an isolated section of a cornfield was chosen as a new county seat.

Two
THE GERMAN ELEMENT

Belleville grew from an 1840 village census of 2,000 to a city of 7,500 in 1860; two-thirds of the population were German immigrants. Germans planted numerous cultural roots, such as the 1842 Belleville Female Institute, 1850 Belleville School Association, several German language newspapers, and merger of the German Library Society and Belleville Saengerbund in 1859.

Belleville Saengerbund singing society was a popular activity in the 1850s. The Westlichen Saengerbund held a three-day festival in 1857 at Eimersberg, brewer Simon Eimer's beer garden overlooking South Side Park. The 1880 Kronthal Liedertafel Chorus, pictured here, performed with the Belleville Philharmonic. The group practiced at Jacob Brosius' home, 735 East Main. After each concert, a Tanzkranzchen, or dancing party, was held for all who attended the concert. Gustave Neubert, director of singing, is front row left and George Rebhan, the Kronthal president, is front row right.

An 1854 newspaper headline cited a shortage of homes; another headline a year later proclaimed business was booming. Belleville was increasingly becoming an important place, largely due to "the German element."

The growth of Belleville's German immigrant population did much to put Belleville on the map as an urban and cultural center.

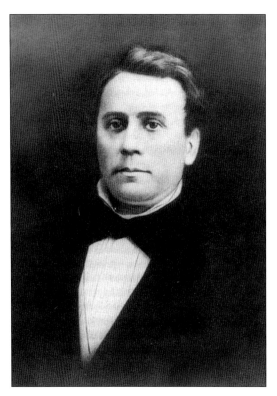

Gustave P. Koerner began using the term "German element" in his writings and speeches—he became the recognized leader of immigrant Germans—to describe the political, economic, and cultural impact of his former countrymen. In the 1830s, he rode the legal circuit and wrote about sharing a bed, "spoon like," with the judge and state's attorney. He described the courthouse at Kaskaskia as, "a mere barn without fireplaces . . . some of the window panes broken." Judge Breese sat on the bench in his great coat with a handkerchief tied round his head. Koerner was elected lieutenant governor as a Democrat, but helped found the Republican party to rid the nation of slavery.

Adam Wilson Snyder was the Democratic candidate for governor of Illinois at the time of his death in May 1842. Snyder was a fuller and wool carder by trade and later became a lawyer. He served as a captain in the Black Hawk War, was elected to one term in Congress, and took Gustave Koerner as a law partner. His home was demolished in 1917 to make way for a new post office at North First and West A.

U.S. Senator Sidney Breese, a strong railroad supporter, was defeated for reelection by war hero Democrat James Shields, who had been wounded in the Mexican War. A cynical Breese backer noted the impact of the "Mexican bullet." "What a wonderful shot that was! The bullet went clean through Shields without hurting him, or even leaving a scar, and killed Breese a thousand miles away." Shields was shot through the lung in the battle of Cerro Gordo and was feted in Belleville and St. Louis in April 1848.

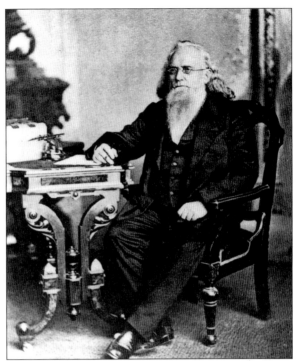

American Notes author Charles Dickens visited Belleville and stayed at the Mansion House. Judge Sidney Breese was told by Koerner and Shields that Dickens would like to sit on the bench while Breese conducted a trial. Breese bristled, "he is one of those puffed up Englishmen who when they get home use their pens to ridicule and traduce us. He can come in like any other mortal." Dickens did not visit the courthouse. The Mansion House was located on the northeast corner of Eastman and High.

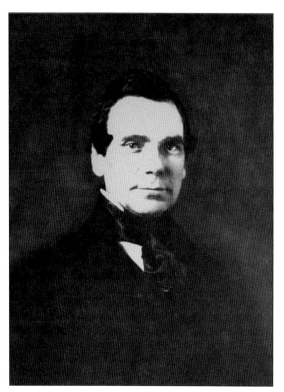

James Shields practiced law in Belleville with Gustave Koerner in the late 1830s. Shields was elected to the Illinois House. At a fellow Democrat's election banquet, Shields and Stephen Douglas, "the Little Giant," climbed up on the table, "encircled each other's waists, and to the tune of a rollicking song, pirouetted down the length of the table, shouting, singing and kicking dishes, glasses and everything right and left, helter-skelter." Shields is the only person elected to the U.S. Senate to represent three states—Illinois, Minnesota and Missouri.

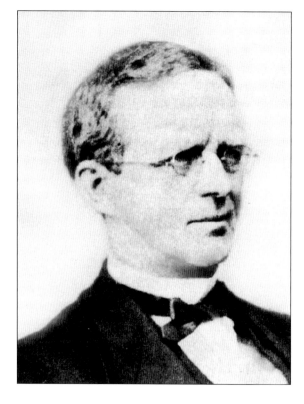

Lyman Trumbull came to Belleville in the late 1830s to practice law. Trumbull was challenged to a duel in 1838, but James Shields intervened, saying he could not be a witness to murder. Trumbull was elected U.S. Senator in 1855—after Abraham Lincoln directed his supporters to vote for Trumbull—as the national debate raged on expanding slavery to new territories. Trumbull, "the magnificent hairsplitter," wrote legislation establishing the Freedman's Bureau, the first Civil Rights Act, and Thirteenth Amendment, which abolished slavery.

In the 1840,s Belleville lawyer James Shields was elected State Auditor and was attacked in newspaper articles attributed to Lincoln. Shields challenged Lincoln to a duel and Lincoln accepted, selecting broadswords, which would give the long limbed Lincoln the advantage. Shields reconsidered and a settlement was arranged. Lincoln later appointed Shields to the rank of General in the Union army. Shields twice engaged Confederate Gen. Thomas "Stonewall" Jackson in Virginia battles, winning the first and losing the second.

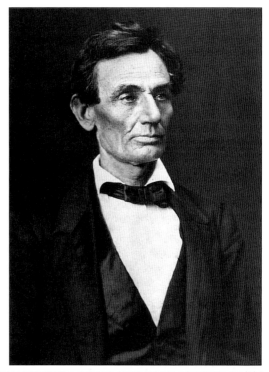

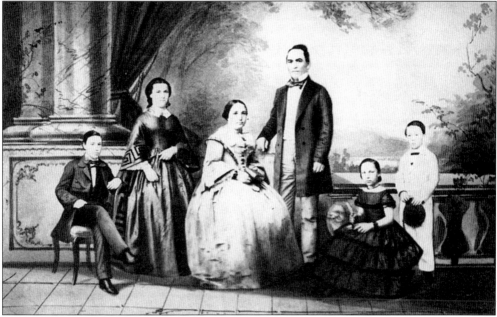

German-born John Scheel arrived in St. Clair county in 1833. He married Elizabeth Engelmann, Sophia Koerner's sister. Scheel was elected county treasurer and county clerk. Lt. Gov. Gustave Koerner, a strong Lincoln backer, took him to visit Belleville Republicans while Lincoln was here for a 1856 speech, stopping at the Scheel residence in the 200 block of South Illinois Street. Lincoln appointed Scheel the 12th District Assessor of Internal Revenue in 1862. Lincoln ended his speech with "God bless the Dutch," a reference to the German love of freedom.

Col. William Bissell, a Mexican War veteran who served under Gen. Zachary Taylor, came to Belleville to practice law. Bissell was elected to Congress and during a debate it was asserted that Col. Jefferson Davis' Mississippi Rifles unit played the decisive role in the battle of Buena Vista, which Bissell disputed. A duel was arranged, but was stopped by Davis' father in law, Zachary Taylor, who threatened to have Davis arrested. Lincoln was urged to run for governor in 1856, but declined in favor of Bissell, a war hero, who became the first Republican Illinois governor.

Mary Kinney was a fun-loving, 12-year-old in 1859 when she stayed in Springfield with her uncle, Governor William Bissell. One afternoon, she tiptoed across the upstairs floor of the governor's mansion, peered through the shutters of the door, and saw Uncle William engaged in conversation with Abraham Lincoln. She locked the door and told them she would not open it until she was promised "the best sack of candy" that could be purchased in Springfield. The ransom was sweetly satisfied. Mary married Gustavus A. Koerner, son of Lt. Gov. Gustave P. Koerner, and is pictured here with her daughter Dorothy and son Kent.

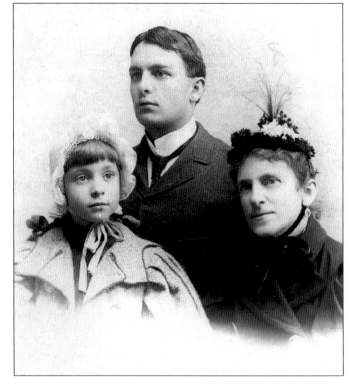

In 1848, Col. J.L.D. Morrison wrote fellow Whig Congressman Abraham Lincoln, advising him how to attract German voters. He stated that Whigs should "dissolve" themselves of "nativism" (anti-immigrant views) and "many Germans will join us…and it is worth the effort to conciliate them." Morrison added, "if Mrs. Lincoln accompanied you to Washington pay my respects to her—and tell her to laugh as much as she pleases at the fantastic asses who will swell this winter at Washington." Morrison was judged to be the richest man in 1870s St. Clair county, based on taxes paid.

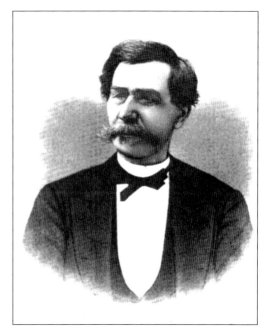

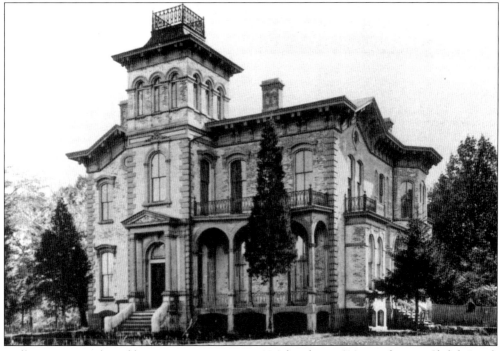

William Kinney, elected lieutenant governor in 1826, lived on a 600-acre farm on Shiloh Road, east of Belleville. Kinney was a pro-slavery preacher, farmer, and "whole hog" Jackson Democrat. Kinney lost bids for governor in 1830 and 1834. He was considered an active campaigner who "went forth electioneering with the Bible in one pocket and a bottle of whiskey in the other and thus he could preach to one set of men and drink with another and thus make himself agreeable to all." Col. J.L.D. Morrison would later purchase Kinney's farm and build "Glen Addie," pictured here, which was named for his wife, Adele.

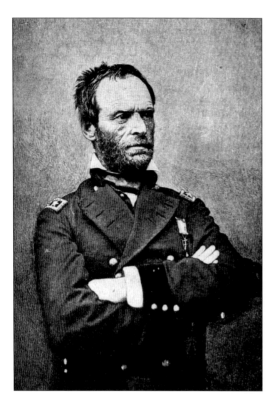

Gen. William T. Sherman attended a New Year's dinner at Glen Addie in 1869. In 1837, Sherman called on Lt. Gov. William Kinney in Belleville when Kinney was commissioner of Internal Improvements and Sherman was surveying a proposed railroad line. Sherman enjoyed his dinner and, according to Gustave Koerner's memoirs, he began "dancing the quadrille, with high steps and bold jumps" and later "fell to kissing young girls of French descent" who were visiting from St. Louis.

Ulysses S. Grant got his first Civil War assignment reviewing soldiers' training through the intercession of Gustave Koerner, aid to Gov. Richard Yates. Grant visited St. Clair County Fairgrounds where two companies of Belleville soldiers were camped. Koerner and Grant had supper with the men. "Belleville citizens had sent beer and wine in very liberal quantities. We had a good time amongst the boys," Koerner said the next day. Koerner arranged transportation for Grant to inspect troops camped at Caseyville. Koerner later would severely criticize Grant's action at the battle of Shiloh, where Belleville men were lost.

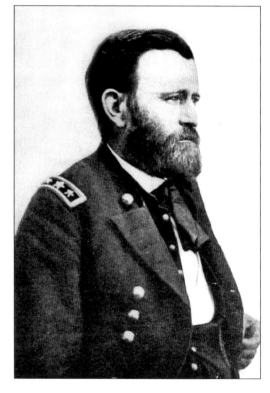

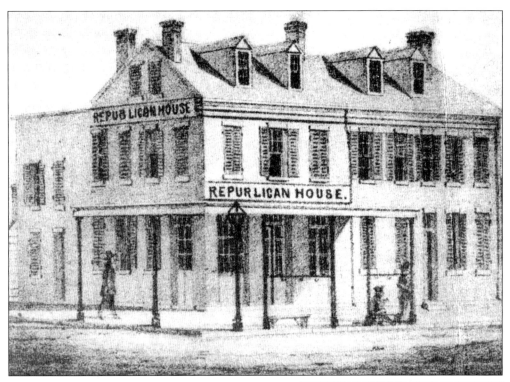

The Republican House, at the southeast corner of South Illinois and Lincoln, was built after Abraham Lincoln's 1856 campaign visit to Belleville for presidential candidate John Freemont and gubernatorial candidate William Bissell. Lincoln's speech was applauded by the *Advocate* newspaper as "one of the most thrilling bursts of eloquence ever uttered in behalf of liberty and the toiling millions." The Republican House was renting rooms and serving food and drink by 1860. The building, and adjacent Scheel-Hilgard home, was demolished in 1919 to make room for Central Junior High School.

Belleville's civic and business leaders sought a rail line connection in the 1840s. The *Advocate* editorialized in 1849 that " Belleville will become a ghost town" unless a rail extension was secured. Col. J.L.D. Morrison served as president of the Belleville-Illinois Town Railroad in 1852, connecting the city to St. Louis. Two years later, the first locomotive was named the "Colonel Morrison" and a shipment of 1,000 hogs was noted. By 1856, 25 to 30 carloads of coal were shipped daily to St. Louis. The Belleville line later consolidated with the Terre Haute and Alton and became known as Terre Haute, Alton, and St. Louis Railroad

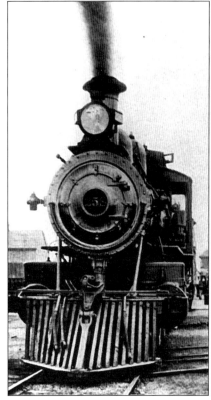

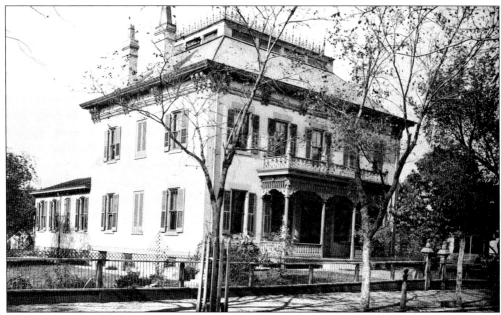

Colonel John Thomas amassed "four thousand acres of the finest farmland " in the Shiloh Valley-O'Fallon area. He was born in Virginia in 1800 and settled in Shiloh Valley in 1818. Elected to the Illinois House in 1838, he sponsored a move to organize a society to "bring justice to thieves, robbers and swindlers." Thomas built a four-story hotel, called the Thomas House, in 1854 at the northwest corner of High and Main Streets, not far from his substantial home, pictured here. Thomas was active in forming the Republican party in 1858.

In 1851, John Winter, pictured here, purchased the 1844 Knoebel Hotel, on the southeast corner of the public square, refurbished it and renamed it Belleville House. Winter operated the hotel until 1857 when Herman Burkhart bought it. Burkhart was elected mayor in 1864, but he and three aldermen resigned in protest when the city council removed a public park and other improvements in front of the courthouse. Burkhart moved to St. Louis. The park was replaced later.

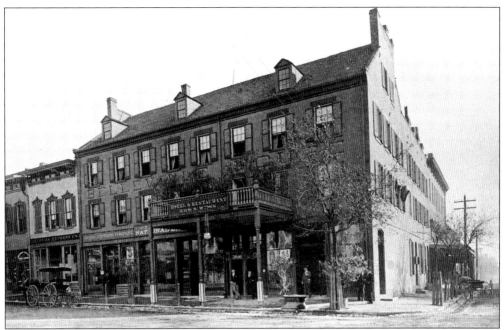

With the completion of the "Macadamized Road" to St. Louis, business in Belleville increased to such an extent that there was a demand for better passenger service to St. Louis. The stage left immediately after breakfast from John Winter's Belleville House. The fare was 25¢ and the roundtrip was rumored to take only three hours. Belleville House diners enjoyed the restaurant's specialty—white asparagus.

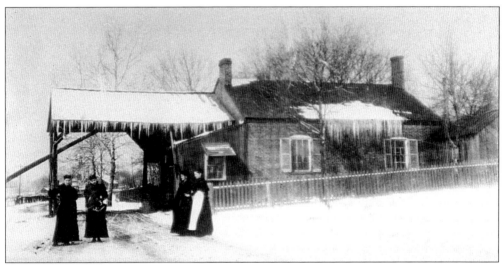

Four plank road companies offered connections to nearby towns beginning in the 1850s. Belleville Urbanna Plank Road company, linking Freeburg to Belleville, formed in 1853, charging 3¢ per mile for a two-horse team. Belleville Mascoutah Plank Road company formed in 1854 and had spent $42,000 to complete eight-and-one-half miles by 1856. Belleville and Westfield Plank Road incorporated in 1853 and connected to Shiloh. Belleville Georgetown Plank Road, incorporated in 1866, ran to Smithton. Pictured here is the Westfield toll gate on Lebanon Avenue.

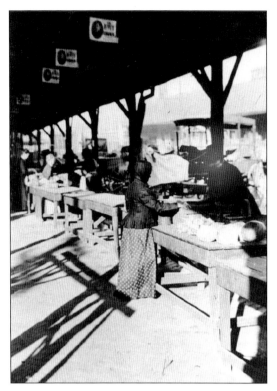

Earliest mention of Belleville's Market Square was an 1838 newspaper article stating it would be open Tuesday and Friday until nine o'clock. Stalls on the public square in 1846 rented for $10 a year, plus $1 for the license. The market square was moved in 1855 to the block between North Illinois, East "A," and North High Streets. By 1934, market square was a parking lot.

West Belleville was established with 150 inhabitants in 1852. It has been reported that residents of the village rarely heard English spoken, for there was not a single American there. Thirty years later, the area had grown to 2,720 residents with coal mines, the Western Brewery (later Stag Brewery), and Waltman's Distillery among the largest employers. Residents could have purchased hats, shoes, and clothing from Mrs. Clarence Schmidt, who operated this store at 1013 West Main.

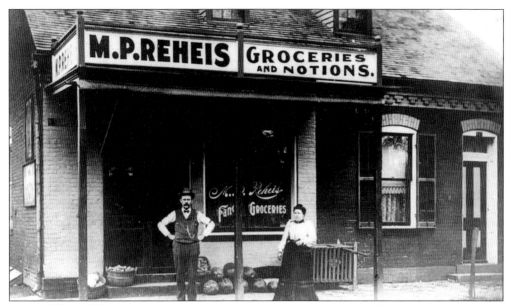

At Twelfth and West Main, Michael Reheis operated a grocery store for 20 years, then sold it to go into the real estate business. West Belleville was laid out in 230 residential lots, which sold for $50–75 per lot. The small, cohesive community provided for widows and orphans by forming the West Belleville Workingmen's Society in 1866. West Belleville annexed to Belleville in 1882.

The German American Folk House, the working man's residence pictured here, was a simple, efficient use of space based on German homeland design. The Belleville Historic Preservation Commission describes the house as "a one and a half story brick house with gabled side walls and a cornice of fancy brickwork across the front, four chimneys in pairs inside the gable walls, regularly spaced, arched window and door openings and a transom over the door to draw a cool breeze through the house in summer." Pictured at right are John and Lydia Dintelmann, their daughter Dorothy, and, at left, John's sister Margaret at their home on State Street Road.

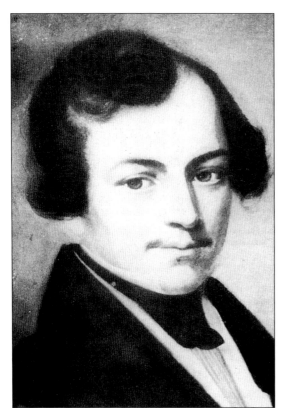

When Belleville switched from the village form of government in 1850, Theodore Kraft was elected mayor of the city. Kraft came to Belleville in the 1830s and married Mary Mitchell in 1838. He engaged in merchandizing until 1840, farmed for six years, and earned a law degree in 1849. He was elected justice of the peace for 20 years. Kraft owned a life insurance agency and also invested in real estate, laying out the village of Mechanicsburg, later changed to Mascoutah, in 1839. He also donated the land for a school that was operated by St. Paul Church at the site of the present Franklin school on North Second Street.

Francis M. Middlecoff, pictured here, and Theophilus Harrison purchased the threshing machine company of Cyrus Roberts and John Cox in 1855. Belleville Foundry and Agricultural Works manufactured the "Belleville Separator," a thresher and cleaner, as well as hay rakes, wood saws, lard presses, and corn and cob crushers. The company became known as Harrison Machine Works—at today's location of St. Elizabeth Hospital—and produced the famous Harrison Steam Engine. Harrison closed in 1950.

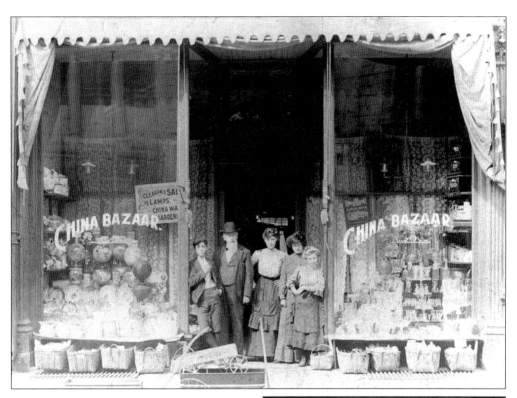

Shopkeeper Charles Drees opened his "China Bazaar" at 218 East Main around 1863. His china and crockery store did so well that when he sold to Krebs and Company in 1896, the store was known as the "Crystal Palace." Charles Abend, a man on his own since age 11, developed quite a reputation as an amiable clerk and successful store owner. Abend purchased the three-story Krebs operation in 1912.

Rufus Melcher emigrated to Belleville from Maine. He married his wife Rhoda in Ohio and briefly settled in Indiana before moving to Illinois. Their oldest son, Orin, was born in Belleville in 1843. The Melchers held property in Belleville since 1848. When the Catholic community built a new St. Peter's Church in 1866, Rufus crafted all interior doors, wainscoting, and altar carpentry. Family tradition relates Melcher had a fine collection of planes, chisels, and awls. He was a master at mortising and scribing. He made his own glue and sharpened his tools with turkey stone.

35

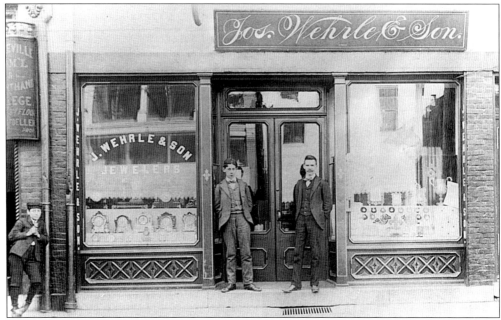

Joseph Wehrle of Baden, Germany, established a jewelry business on the public square in 1854. This photo, taken *c.* 1920, at 16 East Main includes the two sons of watchmaker Fred G. Wehrle—Leroy is at right and Fred J. is at left. The store sold clocks, watches, jewelry, and flatware. The century-old business was closed when Leroy retired in 1956.

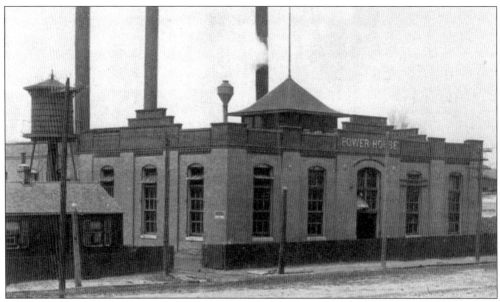

Belleville Gas Light and Coke Company built a plant on Richland Creek at Sixth Street in 1856. Thirty-five gas street lights were installed along West Main, Illinois Street, and South High the next year. The company upgraded equipment in 1901 to assure customers of reliable electric service. In 1902, local investors sold to an eastern syndicate, which became known as St. Clair County Gas and Electric. Due to public demand for consistent electric service, St. Clair sold to Illinois Power and Light Company in 1922.

Bellevillian Dr. John Francis Snyder, son of Congressman Adam Snyder, caught California gold fever and wrote disappointedly in 1850, from Slate Creek, "I can not say I am much pleased with this country. The climate and few facilities for irrigation renders it totally unfit for agriculture and the natural resources of the country are gold and lumber. Lumber can be transported from New York cheaper than it can be got from the mountains." Argonaut Snyder also collected Indian and French relics and mapped and surveyed Cahokia Mounds. He was a founder of the Illinois State Historical Society and society president from 1903 to 1905.

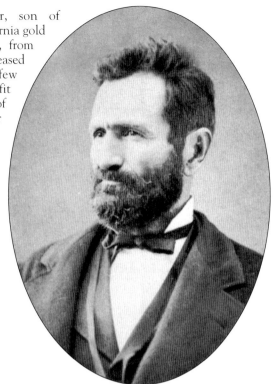

Henry Raab, born 1837, influenced the Belleville and Illinois educational systems. Raab taught in Belleville public schools and advanced to city and county school superintendent positions. In 1855, 14 teachers taught a student body of 682 in 11 rented rooms. By 1880, the city education system had four buildings: Washington, 1865; Franklin, 1867; Bunsen, 1879; and Lincoln School of West Belleville. Raab was elected state superintendent of schools in 1882 and 1890.

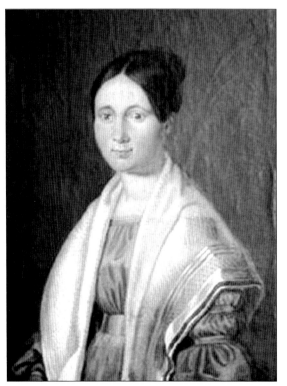

Sophia Engelmann, born in Germany in 1815, emigrated to the United States in 1833 aboard ship with her family and political exile Gustave Koerner, whom she married three years later. Sophia Koerner and Henry Raab worked together to form the Belleville Kindergarten Association in 1874. Sophia, the association president, organized 150 ladies, who sold 70 shares of stock at $30 each to start a kindergarten based on the Froebel system emphasizing play and use of play materials and activities for children. There were 201 pupils enrolled the first year, ranging in age from 3 to 7 years.

Molly Bunsen married Dr. Adolphus Berchelman in 1848. Berchelman was a veteran medical practitioner who emigrated in the early 1830s with other university educated Germans. He was a founding member of the German Library Society in 1836. Molly was president of the Ladies Union of Belleville in 1851 and a member of the Committee on Teachers of the Belleville School Association in 1850.

Marianne Bunsen Steingoetter, shared the family's interest in education. George Bunsen Sr. was county superintendent of schools from 1855 to 1859 and operated a school based on the ideas of Pestalozzi. Marianne was a teacher in Belleville's Kindergarten School in 1877 and continued to be interested in formal and informal education. In 1929, the year of her death, she sponsored a sewing class at the Belleville Public Library for children between the ages of 8 and 14.

On October 16, 1847, Belleville voters elected three school directors, including Charles Elles. He emigrated from France in 1836 and as secretary of the Belleville Literary Society in 1850, he facilitated the purchase of the Odd Fellows Building for use as a school by the Belleville School Association. He was a dry-goods merchant from 1843 to 1897. His wife Nancy, nee Hough, was the first female to teach in Belleville Public Schools. In 1851, there were 952 males and 897 females enrolled in Belleville District 4.

The Belleville Band, the city's first, was organized in 1840. The American Saxe Horn Band, Bavarian Band, and Concordia Band all followed. Music professors led the bands and they performed at weddings, at City Park Theater at Second and "A" Streets, and led parades from tavern to saloon on Sunday evenings. The American Saxe Horn Band "are prepared, at short notice, to meet any call the public may desire." Sunday German beer garden "gemutlichkeit" ran afoul of Anglo Americans quiet observance of the Sabbath, but "volksfest" on Sunday was a German tradition.

The Belleville Philharmonic, the nation's second oldest continuing symphonic orchestra, began in 1867 and has presented at least five concerts a year since then. Philharmonic Hall, at 116 North Jackson, was purchased in 1897 after the building had served as the original kindergarten building. Music exercises the mind, but it can be good for physical health too. Member Alfred Bossard walked 30 miles from his Highland, Illinois, home, carrying his "bull fiddle," to attend concerts and practices in Belleville.

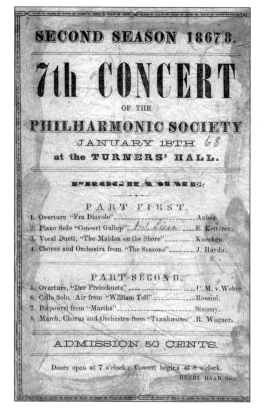

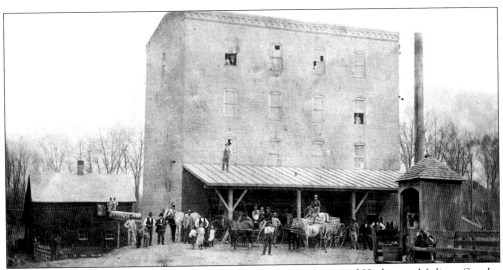

German native Fidel Stoelze came to Belleville in 1850 and married Katherine Molitor. Stoelze was a foreman at Fleischbein and Fassbender Brewery and shortly afterwards built St. Clair Brewery at West Main and Third Streets, the business later became Stoelze Brewery. The operation produced 3,500 barrels in 1882. Stoelze died in 1888, forcing the brewery to close. Nine breweries operated at various times in the 19th century within 12 blocks of downtown: Fleischbein, Anderson, Erhard, Klug's Illinois, Heberer Brothers, Washington, Stoelze, Western, and Southern breweries.

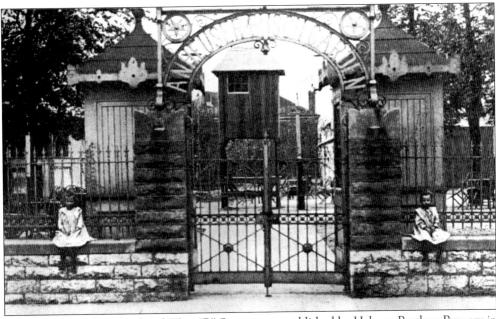

City Park at North Second and West "B" Streets was established by Heberer Brothers Brewery in 1859 as a beer garden/dance hall/ performance area. That year the community celebrated the 100th anniversary of the birth of German poet/dramatist Schiller with speeches and a parade to the park. It changed hands in the 1870s and eventually expanded to seat 1,000 people in the 1880s. A bowling alley was located on the west side of the park. Klug's Illinois Brewery and beer garden operated across the street. For August Busch's involvement in the city park, please see Chapter 3.

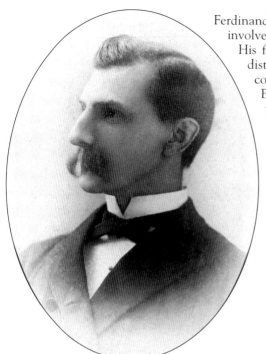

Ferdinand Braun, a maltster from Germany, was involved in coal mining, brick making, and a dairy. His father, Lorenzo, and George Bressler built a distillery in about 1840, which Ferdinand controlled by 1863. Ferdinand incorporated the Belleville City Railway in 1874. Belleville had the first electric rail line in the state. Braun and his wife Wilhelmina returned to Germany in 1891. Ferdinand's brother Charles and father Lorenzo invested in Belleville but lived in St. Louis.

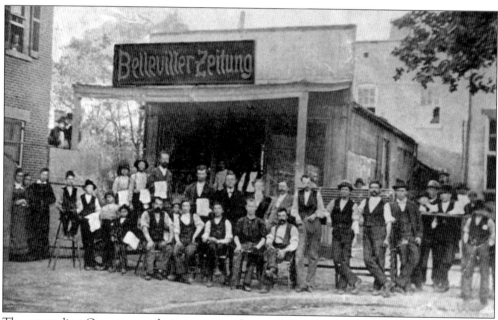

The expanding German population supported several German language newspapers. *Belleville Zeitung*, pictured here, was founded by Theodore Engelmann in 1849. It lasted 74 years and absorbed *Der Stern, Stern Des Westens*, and the *Belleville Post*. Other German papers: *Volksblatt*, 1856; *Deutsche Demokrat*, 1856; *Der Treu Bund*, 1873; *Intelligenz Blatt*, 1884; and *Arbeiter Zeitung*, 1890. German immigrants from the 1830s, the "Grays," were intellectually challenged by the 1848 revolutionists, the "Greens," for leadership of the "German element." In 1917, German papers were banned in Belleville as disloyal to the United States.

Reverend W.F. Boyakin was editor of the Belleville *Democrat* newspaper in 1858. Boyakin said his father saved Gen. Andy Jackson's life in a battle with Creek Indians and Jackson rewarded his friend by sending his son to college. Rev. Boyakin knew Abraham Lincoln and served on General U.S. Grant's staff. Fred Kern and F.W. Kraft bought the *Democrat* in 1891. Kern purchased the *Daily News* in 1901, merging them into the *News Democrat*. Kern was elected congressman and mayor of Belleville. The *News Democrat* acquired the *Advocate* in the late 1950s, becoming the city's only daily paper.

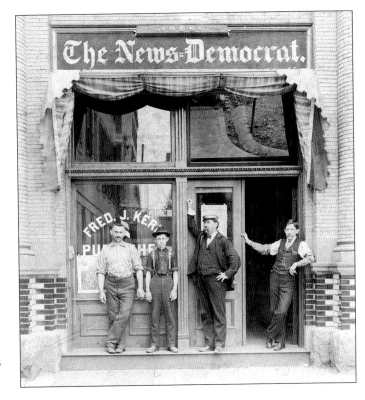

This is the original *Daily Advocate* building in the first block of South High Street. In the late 1830s, Abraham Lincoln urged Rev. Joseph Lemen of O'Fallon to persuade investors to start a newspaper in Belleville. That venture became the *Advocate*. A former editor stated Mark Twain spent several weeks working there while researching J.A. Slade—the "Robin Hood" of the Rocky Mountains—whose brother, James P. Slade, was a Belleville educator. Twain's stint in Belleville was in the late 1860s or early 1870s, when his first book, *Roughing It*, was published.

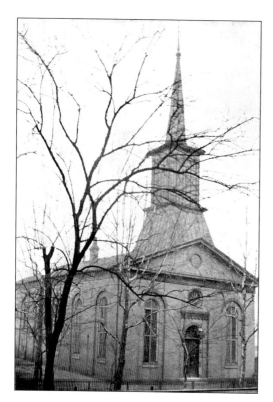

St. Paul's Evangelical Church, organized in the 1830s, is recognized as the first German-speaking Protestant church in Southern Illinois . The first church was built on the site of the present Franklin School. The brick church at 119 West "B" was built in 1861. The congregation invested in a newer church at 111 West "B" and added classrooms, library, an activity center, and a gymnasium.

One of the most well-known women at St. Paul's Evangelical Church was Maria Catherine Neu. In 1861, she founded the Frauenverein and served as president for 25 years. The Frauenverein was a large women's organization which raised operating funds for the church. They sponsored a fall dance at Busch's Opera House and Beer Garden across the street from the church on North Second, a congregational picnic at Eimer's Park and an annual Sunday School Picnic. In 1849, she married Phillip Neu, a West Belleville brewer.

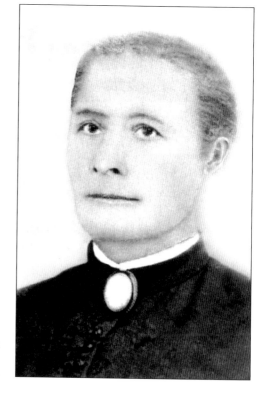

The Methodist Church has a "circuit rider" history in Illinois. Belleville's congregation first met in 1825 at the Dennis school house; the German Methodist congregation organized in 1848 and their church is at 213 South Jackson. German Methodism was a separate branch of the American Methodist-Episcopal church until 1921. In 1950 Belleville's German Methodist congregation merged with First Methodist. This church is no longer used for services.

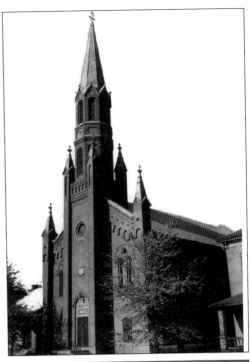

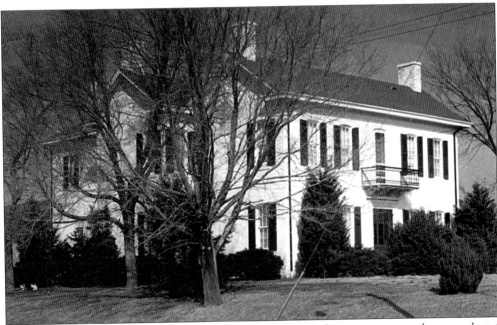

Augustus Chenot, born in France in 1828, operated a farm for many years at the east edge of Belleville. Chenot was president of St. Clair County Farmer's Mutual Fire Insurance company for 35 years and an officer of St. Clair County Fruit Growers Association. Chenot was elected St. Clair County commissioner in 1874. He purchased a home on the northwest corner of "A" and North Pennsylvania after moving from his farm. The farm was transformed in the 1950s into a single-family subdivision. His original dwelling sits proudly at the entrance to Chenot Place on Carlyle Avenue.

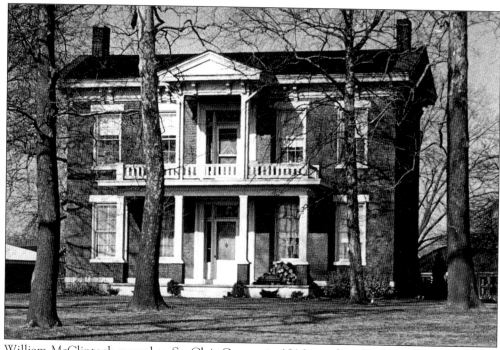

William McClintock moved to St. Clair County in 1816, taught school, and managed stores before being elected justice of the peace, police magistrate, and circuit clerk. He built his home on a 240-acre farm on Mascoutah Avenue. He also owned the northwest corner of the Belleville public square, selling it for $7,000 in 1856. He died in 1886. Green Patterson purchased his home and in 1897 held a reunion of Belleville adventurers who joined the California gold rush. The home is in the 100 block of Mascoutah Avenue on Patterson Court.

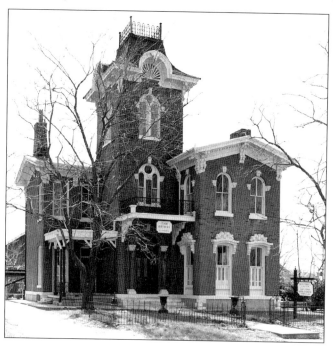

Dr. M.W. Carter of New Hampshire married Melissa Stookey in 1855 and built this Italianate villa at 310 East Washington. Dr. Carter was the first dentist in Belleville in 1852. His handbill describes his practice, "Teeth inserted at the low price of $15–30 a set, other work in proportion." The home was purchased by Arthur Eidman Sr., an organizer of St. Clair National Bank. Eidman served as national president of the American Minute Men, an organization formed to uphold, defend, and preserve American citizenship.

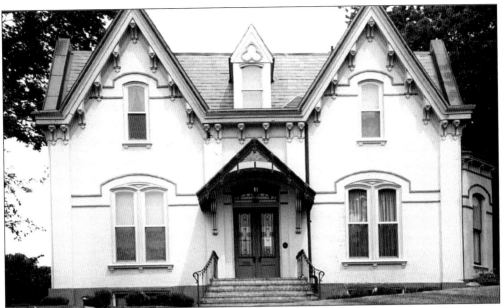

Charles Spoeneman rebuilt and expanded his home at 420 North High in 1903. It has been cited as an excellent example of Gothic architecture. Spoeneman was an iron monger who helped organize numerous foundries, notably Enterprise in 1904. His home is in the Cabanne addition of Belleville platted in 1854. The Cabanne family of St. Louis operated American Fur and invested in Belleville real estate.

Casimir Andel came to Belleville at the start of the Civil War and joined Belleville Germans in the 9th Illinois Infantry and later the 12th Missouri Infantry. Andel was wounded in the arm and mustered out in 1864. He married Louise Kircher in 1871 and built a stately brick home at "D" and North Charles. Andel rose from cashier to president of First National Bank and was active in other businesses. The home was heavily damaged by fire in 1985 and restored by Angie and Judge Jim Donovan. It is an impressive example of historic preservation's positive impact on a neighborhood..

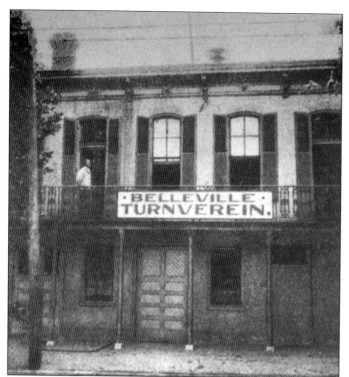

The Belleville Turnverein was organized after the Civil War and emphasized physical and mental growth. A gymnasium school and reading room opened in 1867. German refugees from 1848 influenced the organization and turned it into a political organ, adding marching and musketry exercises to defend themselves against anti-foreigners. Henry Raab reorganized the Turners in 1899, again concentrating on exercise and mental activities. Turners had a membership of 300 adults and 350 children at the turn of the century.

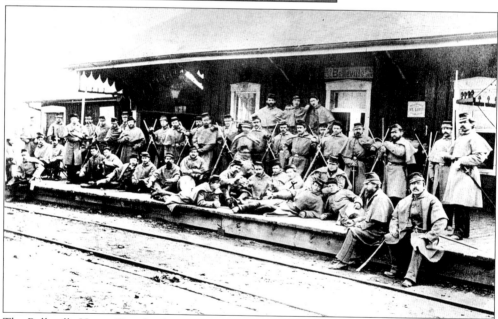

The Belleville Home Guard is first mentioned in 1844. A request two years later by Gov. John Reynolds resulted in J.L.D. Morrison being named captain. It grew to 94 members by the start of the Civil War and was re-named the Constitutional Union Guard to reflect its pro-north sentiment. The guard, 225 members strong, was called out to maintain order during an 1877 railroad strike and captured a strikers' train in West Belleville. The group faded into history and held its first reunion in 1914. Company A is pictured here during the 1877 rail strike.

Emil Rebhan (1820–1898) left Baden, Germany, as a revolutionary in 1849. He was in Missouri during the Civil War and was a friend and business partner of James B. Eads. Rebhan founded Company F of the 2nd Missouri Regiment and fought in the battle of Wilson Creek—the battle that kept Missouri in the Union. Rebhan married Catherine Mueller, the daughter of Christian Mueller, a Mascoutah Road farmer. Rebhan, an engineer, surveyed the Mascoutah and Shiloh Plankroads and retired to farming in Shiloh—occasionally entertaining his friend, James Eads.

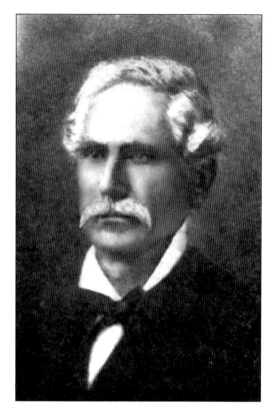

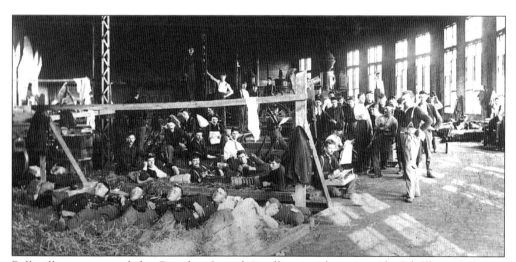

Belleville men responded to President Lincoln's call to arms by joining the 9th Illinois Infantry, 22nd Illinois Infantry, 43rd Illinois Infantry (Gustave Koerner's regiment), and several German regiments formed in St. Louis. These men are stationed at Cairo, Illinois, at the confluence of the Ohio and Mississippi Rivers.

The 9th formed first and fought under Grant at Ft. Donelson and Shiloh, Tennessee, and Corinth, Mississippi. The 22nd fought at Belmont, Sikestown and Tiptonville, Corinth, Chickamauga, and joined Sherman's Atlanta campaign. The 43rd secured the St. Louis area before engaging Nathan Bedford Forest in Tennessee.

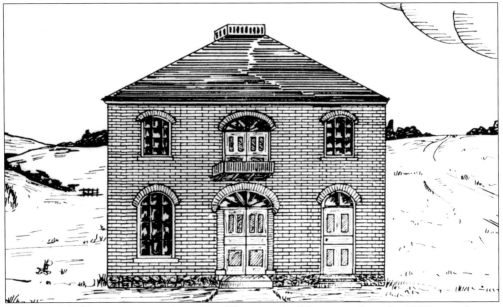

By the mid-1850s, newspapers editorialized for a new building to replace the 1830s courthouse, "a slob-sided, peeked topped, country school house looking little concern that looms up in the public square of the city." If that didn't paint an unattractive picture, consider this description from another editorial: "it is an eyesore, uncouth and with proportions supremely ridiculous." The courthouse, the original reason for Belleville's existence, had to reflect the city's emerging role in the region.

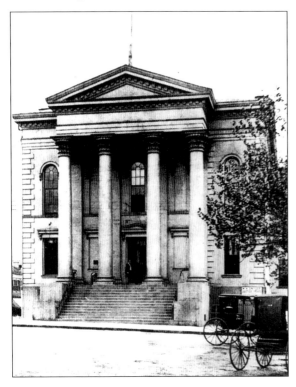

Construction of a new courthouse began in 1857 and was completed in 1861. The structure is considered a "mixture of Roman and Greek architecture. The Roman arch in lintels of the second story windows and huge Greek columns supporting the portico displays the mixture of features." It also was described as one of the finest examples of classic Greek Revival architecture in Southern Illinois. The governmental icon now dominated the public square—it symbolized power and reflected the self-image of Bellevillians.

Three

FIFTY YEARS OF
INDUSTRIAL GROWTH

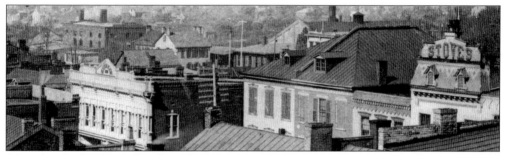

After the Civil War, Belleville rushed into manufacturing. Budding industrialists expanded a manufacturing tradition begun in 1848 with agricultural equipment, carriage manufacturing, wagon making, milling, distilling, and brewing.

In the 1870s, coal mining grew rapidly and railroads were in place to transport raw materials and manufactured goods to market. Belleville, a land-locked community, did not have the advantage of river transportation. Local entrepreneurs, boosters, and politicians never lost sight of railroading. St. Clair County coal fields provided the cheapest of fuels and waves of German and English immigrants dug coal to run the furnaces, cupolas, and hammers of industry. Skilled miners were in great demand and many settled in West Belleville. Inventors were heroes. The demand for workers was unrelenting. Belleville's steam powered smokestack industries were labor intensive.

Belleville's greatest industry, the manufacturing of stoves, began in 1873. By 1890, Belleville was a well-known supply center and was known for its diversity of product. Belleville-made products served a local market, St. Louis, and the developing West—from the Mississippi River to the Pacific Ocean. These were prosperous times but the workingman shifted from intense activity to no activity at all; and no paycheck. Friederich Karch, a 48er living in Belleville, is quoted, "A sick man is a poor man." George C. Bunsen, reformer, is quoted as saying, "When a man is steady and sober, and finds himself in debt for a common living, something must be wrong." A country-wide depression created by overproduction and speculation in the West created havoc for the industrialist and the worker. After five years, from 1893 to 1898, reforms were enacted. The gold standard became a reality in 1900 and the Erdman Act authorized government mediation in labor disputes involving interstate commerce.

America was in transition the first half of the 20th century. Difficult strikes, socialism, women's suffrage, and two world wars were to affect every American. But Belleville's industrial wealth and the labor of many created a well-built community with a strong institutional and ecclesiastical life—a life which perseveres to this day. The workingman successfully organized for an eight-hour day, a safer workplace, and for a living wage that did not include the labor of his children.

This mid- to late 1800s view of West Main Street faces the northwest from the public square.

Col. James Waugh and his sons, James C. and Robert, moved the St. Louis Bogy Nail Mill to Belleville in 1869. The plant and rolling mill shipped worldwide and was the only successful mill in the State of Illinois. An attempt by Waugh Mills in 1890 to manufacture steel rail failed because of a lack of water, even though the mill was located directly behind the present-day Southside Park lake, which frequently ran dry. The Mill was purchased by Valley Steel of Missouri which operated two mills in Belleville but closed them both by the turn of the century. The Waugh Mill was demolished when it was purchased by Illinois Central Railroad Co.

Simion Bunn, a foundry man from Pennsylvania, became a furnace builder for Belleville Steel Co., which operated two mills in the city, Valley Mill and West Mill, both an outgrowth of the Belleville and Waugh Nail Mills. In 1871, Bunn patented a Puddling Furnace and in 1886 a "double decker" nail plate furnace. In 1910, Simion Bunn Sr., age 65, installed an annealing and smelting furnace for the Allegheny Valley Malleable Iron Co. of Missouri. In his spare time he led a brass band, playing the trumpet and bugle. He died October 11, 1913.

George Marshall emigrated to America from England in 1848. He was an engineer and a patentee. In 1878, the year he died, he was awarded two patents: one for an apparatus to wall wells and another for a sectional steam generator. Marshall was the secretary/treasurer of Belleville Pump & Skein, a company he and a partner founded in 1870. His patents reflect the need for steam as power.

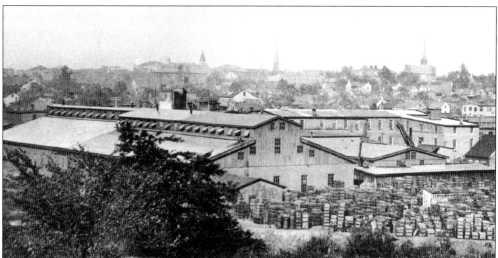

Belleville Pump & Skein was established in 1870, and by 1880 was a giant in manufacturing and machine tooling, installing the only steam hammer in Belleville and the largest in Southern Illinois. Col. John Thomas and his son, James, invested heavily in the company. In 1885, the product line changed from letter-copying presses, jack screws, steam pumps, boilers, and plows to stoves. The Pump & Skein Works became the parent of Belleville Stove and Range Works. By 1927, the Pump & Skein was no longer part of the Belleville industrial scene and Belleville Stove suffered a disastrous fire, which destroyed six buildings amounting to a one million dollar loss. The company did not survive the depression.

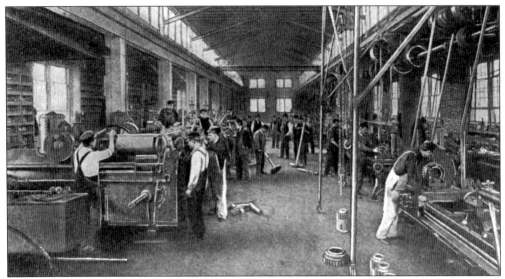

Harrison Machine Works, established in 1848, was a major player in Belleville's industrial history. The company made agricultural equipment by hand and, through patented improvements, continually strived to increase the durability of their product. HMW equipment is prized to this day. Steam traction engines, and separators such as the "Colorado Special," the "Great Western," and the "Belleville Baler" are especially collectible. HMW was the sole licensee of the Belleville Baler and its improved baling press. Their six-acre plant was located on South 3rd Street and by 1880 employed 200 men.

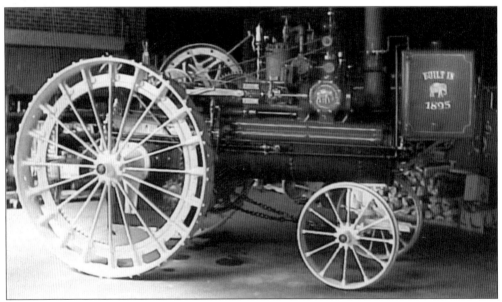

This 12-horsepower steam engine was built by HMW in 1895 at a cost of $1,300 and weighed 11,000 lbs. Traction engines were used year round and not just by grain farmers. They were used in road building, grading, hauling, dredging, and house moving. The brick-making industry used the engines to pull clay loaders and clay plows. According to Ittner Brick of Belleville and St. Louis, one HMW engine "could do the work of 25 horses." The "Jumbo" pictured here is the largest artifact in the Labor & Industry Museum's collection.

Numerous activities brought national attention to Cyrus Thompson. In 1905, Illinois Governor Deneen appointed Cyrus Thompson president of the Illinois Committee to the Lewis & Clark Centennial Exposition, Portland, Oregon. He enjoyed a well-known reputation as a big game hunter who wrote about his exploits in national magazines. Thompson was president of Harrison Machine Works from 1902 to 1927.

Jacob Rentchler came west from Union Co., PA in 1837 with $21,000 and settled on 800 acres. Rentchler was a stock trader and owned the franchise to manufacture the "Pennock Grain Drill" in the State of Illinois. By 1870, the family employed 60 to 80 men in the manufacture of IXL grain drills and seed sowers in Belleville, and shipped to Southern Illinois, Missouri, Kansas, Nebraska, and Iowa. Pictured is Henry, co-owner of the Belleville Agricultural Works, and his wife Evalyn.

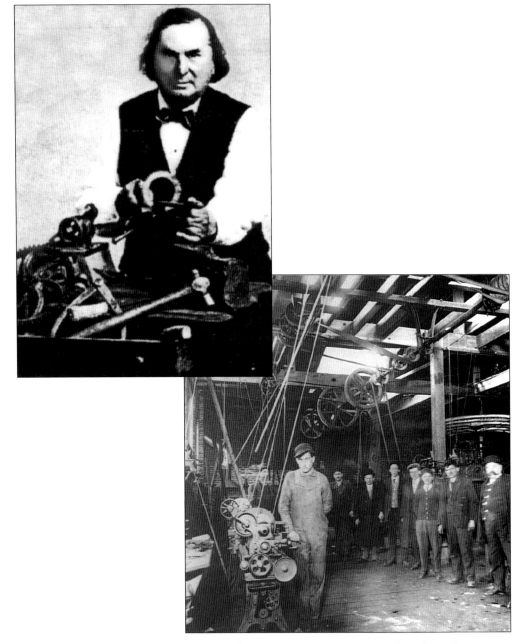

Philipp M. Gundlach, pictured above, was born in 1831 in Germany to a long line of inventors, mechanics, and tinkerers. The earliest operated a furnace in Grossalmerode, Germany, in 1799. In America, new inventions and improvements to farm equipment were a major influence in the second half of the 19th century when thousands of people were heading West. The Gundlachs of Belleville were part of that movement. P.M. Gundlach and Beno J. Gundlach Machine Co. received patents for grain drills, grain flukes, hay rakes, wheel hubs, and industrial cutters of all kinds. The Gundlach inventive influence has also been felt in the automobile industry and, in more recent times, the coal industry with T.J. Gundlach Machine Co. Pictured above is the Beno J. Gundlach Machine Co. on North Eighth Street near West Main Street.

Caroline Fleming is the only Belleville female to receive a patent in the 19th century. In 1868, the U.S. Patent Office awarded her a patent on the improvement of an agitating clothes washing machine. She was born in Belleville in 1832 to Robert K. Fleming, a printer and publisher of the *Kaskaskia Recorder* and the *St. Clair Gazette*. The Flemings emigrated from Pennsylvania to Belleville via Kaskaskia, Illinois. Fleming's inventive career ended with this single patent, which partially relieved the washday burden.

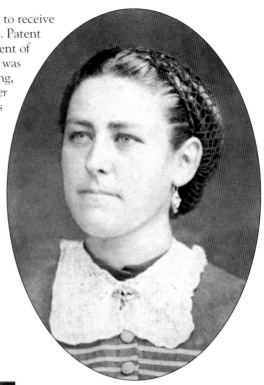

Worden Penn received 20 patents for his agricultural equipment improvements between 1859 and 1869, a period when Belleville was a nexus of agricultural manufacturing. Penn maintained an agricultural warehouse on East Main Street, but sold out to J.B. Rentchler in 1862. Penn, a machinist, mechanic, and inventor chose to live in obscurity. The Penn family originated in Virginia emigrated to Kentucky, where Worden was born. Penn is pictured here with his wife, Mary Margaretha McNiley, whom he married in 1853. Other important Belleville agricultural inventors were Gundlach, Geiss, Brosius, Opp, Boul, Rentchler, and Heaton.

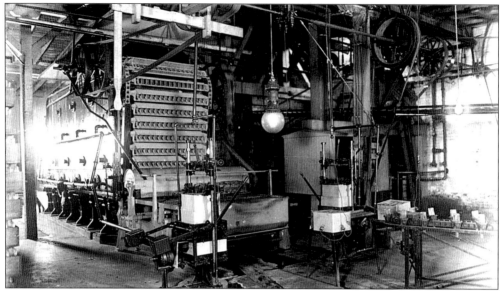

Pictured are the annealing ovens of the Port Glass Co., at the corner of Lebanon Avenue and West Boulevard. In 1902, the Commercial Club of Belleville paved the way for an additional glass plant. Port, headquartered at Muncie, Indiana, opened the plant in 1903. Per an agreement with the Commercial Club, it was required to employ no fewer than 100 employees. It is interesting to note that the negotiations represented Belleville as a community which had raw materials, fuel, and transportation in great abundance, and a skilled workforce. City sewer, water, and gas were also available. In 1903 and 1904, workers went on strike both for wages and for a better definition of the role machinery and technology would play in their industry. Ball Brothers purchased Port Glass in 1905 and closed the plant with workers picketing in 1909.

John Totsch, a laborer in various capacities for 40 years, felt very lucky when he found employment at Belleville Glass Works in 1891 as a glass gatherer. Five years later, he achieved the prideful distinction of "glassblower" and had this photo taken with a bowler hat—a favorite of glassblowers. In 1903, he was elected vice president of Glassworkers Local 9509.

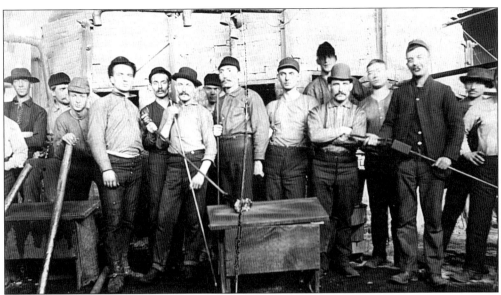

Belleville Glass Works, founded in 1882, was located on the Cairo Short Line in West Belleville, but by 1886 it was bankrupt and in receivership. Adolphus Busch of St. Louis, Missouri, had a great need for bottles and purchased the business. He modernized the plant, and in 1890 employed 100 men with a weekly payroll of $1,700. Wages averaged $10 per week with the glassblowers receiving the highest wage. The plant was expanded in 1891, but it was still a hand plant. In conjunction with dazzling people at the St. Louis World's Fair in 1904, Busch built a 22-ring plant near his brewery in St. Louis. This was the demise of Busch Glass Works at Belleville. The plant closed in 1909.

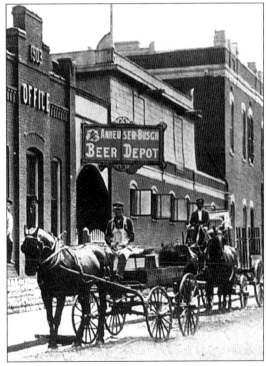

In 1861, Adolphus Busch married Eberhard Anheuser's daughter, Lilly, and by 1880 Busch took complete charge of the Anheuser-Busch Brewing Company at St. Louis. In the 1890s, he became interested in expanding to the east side. His beer depot is pictured here. Busch owned and operated Busch Glass Works, a beer depot, an opera house, and a park or garden, which was a gathering place for Belleville's German families. He was a regular visitor to our community, as were many St. Louis German families. His opera house and gardens were so popular that in 1903 he was granted permission to build a railroad switch from the Southern Railroad to his opera house and beer garden at West "A" and North Second Streets.

Robert Rogers, a foundry man from Ohio with an Irish ancestry, emigrated to Belleville. Two of his sons, Eddy P. and George B., apprenticed at J&R Rogers Iron & Brass Foundry and Rogers Foundry in Belleville. In 1891, the brothers leased City Foundry & Machine Works at South Third and Harrison. By 1896, they had moved their foundry to the new industrial area developing north of the city, near East "B" Street and Iowa, and renamed their foundry Excelsior. Initially, they manufactured sugar kettles, hollow ware, and corn and feed mills, then boiler fronts and structural works. A small mill "that any up-to-date farmer would need" weighed 650 lbs. Excelsior Foundry remained in the Rogers family, supplying gray iron castings for industry until it closed in 2003. Pictured is Eddy Rogers.

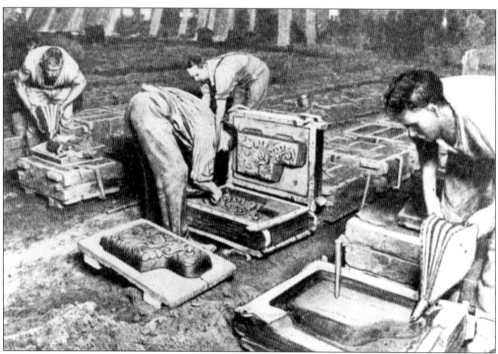

Pictured are employees of Rogers Foundry and Stove Co., c. 1884.

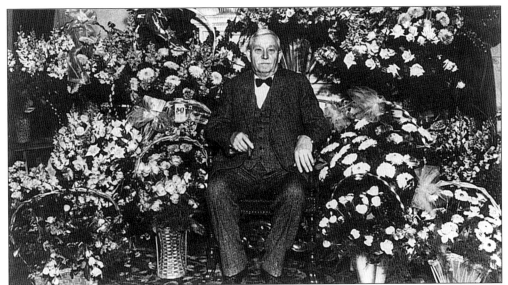

In the *News-Democrat* "Builders of Belleville" series, it was reported "that it would take a six mile train of 800 cars to move Eagle's annual output of 100,000 units of gas, bungalow and circulation ranges and heaters valued at $1,770,000 which are delivered to every section of this country."

In 1874 at age 13, Gottlieb Klemme, a brickyard employee, worked a 12-hour day for one dollar in wages. At age 16, he became an apprentice moulder, but his wages were still just one dollar a day. In 1933, the American Enameler featured Klemme, a 50-year veteran of the foundry and enameling industries, on the front page of its February issue. Eagle started out as a jobbing foundry, casting the "Star Cannon" and the "St. Louis Cannon," but in the early 1920s merchandized its own line. The names Klemme and Eagle are synonymous as three sons and a son-in-law joined the company. The Eagle product line was purchased by Belleville's Peerless-Premier Appliance Co. in 1981.

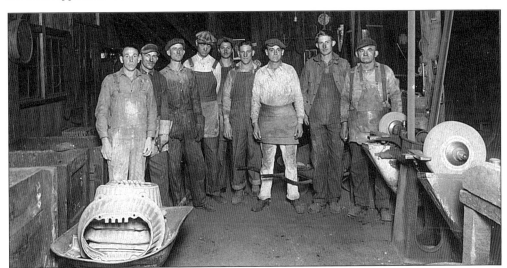

Peter Diehl spent his entire working career in smokestack industries, moving from Belleville's glass houses to foundries. He is pictured, third from the right, with a group of moulders in 1911. It was common for moulders to get together and job out castings to larger foundries. Moulder owned and operated foundries were Supreme, Harmony, Lincoln, Egyptian, and Hi-Grade.

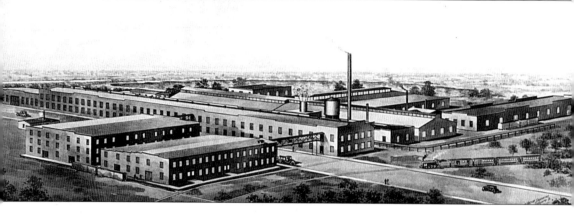

All smokestack industries in Belleville had a railroad siding. Moving manufactured goods and raw materials was paramount. In 1885, Belleville Stove manufactured 20,000 gasoline stoves for the St. Louis market and 27,500 cast iron parlor and cook stoves annually. The hand-made stoves were crated and shipped across the country by rail and have been found in all parts of America—former President Nixon's boyhood home at Yorba Linda, California; a bed and breakfast at Carmel by the Sea; in Alaska; Colorado; Wyoming; Washington; New York; Florida; etc. Belleville Stove Works did not recover from a devastating fire in 1927 and later the Great Depression. The famous St. Clair Stove Line was picked up by Enterprise Foundry of Belleville. Pictured is Belleville Stove at 700 South Third Street, now the offices of and warehouse of Belleville Supply Co.

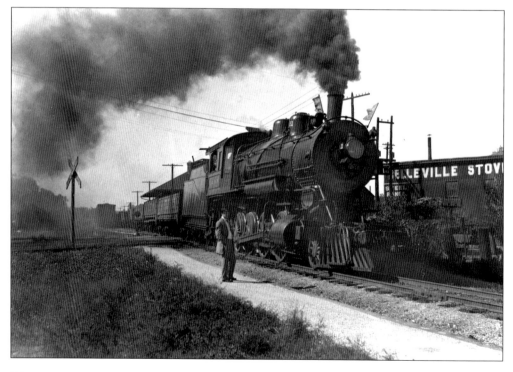

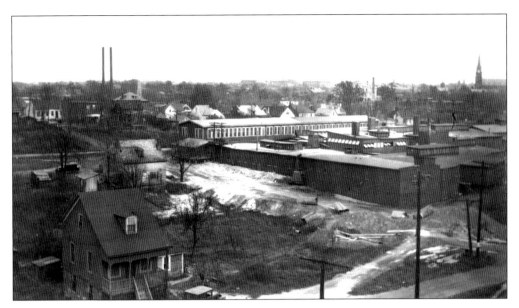

Karr Range enameled the first stove in America in 1900. Covering iron with liquid glass was developed in Germany and German craftsmen were recruited to work in Belleville's stove and casting industries. Karr Range began as a sideline for brothers Theodore and Adam Karr in 1896, but grew to become a leading producer of giant cast iron zone "pot bellies" and hotel cooking ranges. Their cast iron enameled ranges have been found throughout the United States in a wide range of colors. Pictured is the Karr Range Plant and a "small size" hotel range. Karr Range, at Seventh and Harrison Streets, closed in 1955.

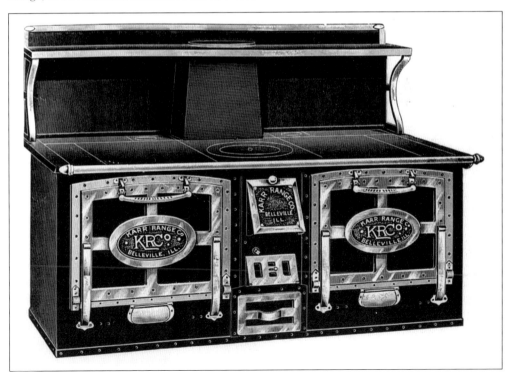

Solomon and Mary Mueller are touring with family and friends. Solomon "Cider" Mueller (at right with hat in hand) operated a farm on Mascoutah Road, but retired to Belleville and invested in Queen City Stove & Range Co. in East St. Louis in 1901. In 1904, he and his partner, Henry A. Lengfelder, changed the name to Orbon Stove and moved the foundry to Belleville. The Weimars, close family friends of the Muellers, include Jacob Weimar (at left with hat in hand), who capitalized Belleville's Ideal Stove in 1909. Orbon became the largest stove foundry in Belleville. Sadly Weimar's Ideal burned to the ground in 1910.

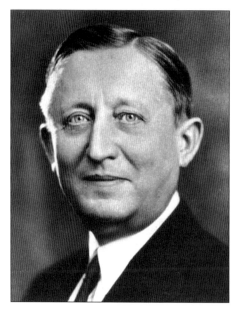

In 1901, Henry A. Lengfelder was 24 when his father, Balthaser, died, leaving him in charge of Lengfelder Stove & Hardware Co. He was interested in manufacturing the stoves that were sold at Lengfelder, so one year later he and Solomon Mueller invested in Queen City Stove & Range Co. It is interesting to note that his wife Anna, the daughter of local founder William Althoff, renamed Queen City "Orbon," which means "good as gold" in French. Lengfelder was president of Orbon from 1918 until his death in 1933 at age 55. As an industrialist, he was also vice president of Peerless Enamel Products Co. and salvaged the M.H. Foundry in 1929

A patternmaker makes the foundry man's mold-forming tool. Conrad Fritz, a patternmaker "educated in Germany under an exacting European taskmaster" emigrated to Belleville in 1872 at the age of 21. The 1887 street directory lists Fritz as an inventor. He also worked at the Belleville Pump & Skein Pattern Shop before opening his own business in 1906. Three major pattern companies at Belleville assisted the casting foundries: Acme, Belleville Pattern Co., and Voss Pattern.

Henry, Jacob, Adam, and Stephen Ehret were born to a family of machinists and foundry workers. Their father, Stephen (1830–1867) was killed in a construction cave in when working on the Elles Building at 20 East Main Street. Jacob, a machinist, patentee, and First Ward Alderman, was killed in an Oakland Foundry gas explosion in 1919. Henry, a molder, was an organizer of Althoff & Ehret, Enterprise Foundry, and finally Oakland Foundry in 1905. Adam, a finisher and partner of Henry, founded Crown Foundry in 1902 and also purchased an interest in Enterprise. Stephen was a blacksmith and machinist who pioneered plumbing contracting in Belleville. The brothers watched their foundries burn numerous times only to rebuild them. Oakland and its sister, Quality Stove & Range, dominated Belleville foundries for more than 60 years and were sold to a New York conglomerate in 1967.

Enterprise Foundry, founded in 1894 to manufacture wood and coal burning stoves, was floundering in 1940. J. Edward Yoch, president of International Coal & Mining Co. and inheritor of the Yoch Mines, rescued Enterprise. In 1961, the one-acre foundry at 1123 East "B" Street was the largest in Belleville. Yoch moved the foundry into core making and thin-shelled gray iron castings—components of gas ranges. In 1961, typical pay for an experienced moulder was $40 per day and they worked with 800 lbs of molten iron at a time. Excelsior bought out Enterprise in 1967.

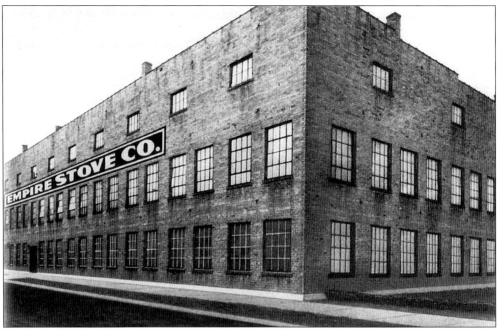

City Stove Works, founded in 1877 on the Freeburg Plank Road, was purchased in 1886 by F.J. Snyder and Joseph Baker. Baker Stove's Cooper Shop remains today as part of the plant of Empire Comfort Systems. Labor problems, a disastrous fire, and the Depression bankrupted one of the biggest stove foundries in Belleville. Henry Bauer Sr., president of Belleville Tin & Sheet Metal Works, purchased Baker-Nagle Stove. Bauer was interested in expanding his business in residential and commercial heating by manufacturing a stove patented by him and Father Frederick Beuckman, a Catholic priest. After the World Wars were over, Empire produced a cooking-range line of eight models plus unit and space heaters. Empire continues to market all manner of "space heating" products. The stove line was dropped in 1951.

In 1915, Joseph P. Roesch, a nickel plater and polisher in Belleville's stove industry and a union member and treasurer of Local No. 138, decided to go into business for himself. He built a cupola in his backyard and peddled his castings. In 1917, Roesch and his brother Arthur, plus Edward A. and Emil J. Kohl, agreed to partner. One year later, Roesch-Kohl Enamel Range Co. was burned to the ground. In 1920, the plant was again destroyed and rebuilt. Roesch discontinued the manufacture of its own stove line in 1932. The firm specialized in fabrication, enameling and "building skins," notably the pretentious Esquire Theatre in Clayton, Missouri; the Falstaff Office Building in St. Louis, Missouri; and the enameled panels of "White Castles." The company continues to manufacture and enamel for industry.

Premier Stove was founded in 1912 by an experienced stover, Klemme of Eagle, and Arthur E. Krebs. Trademark problems forced a change from the original company name, Perfect, to Premier in 1926. As gas and then electric became acceptable for cooking, Premier tooled up with complete lines. Premier's merger with Peerless, a Belleville enameling company, provided an opportunity to become a complete manufacturer. The company continues to ship worldwide, as evidenced by this trade show exhibit at St. Louis, Missouri.

John C. Born and his two sons were quite inventive. They owned six patents in improvements to steam pump, grinding, and lathe equipment and manufactured their product under the name American and Crescent. When Born outgrew his residence and machine shop at 123 North Church Street, which now houses the Labor & Industry Museum, he built a machine shop at the rear. In 1912, his business required another expansion and a new facility was built on two acres of ground at 600 Lebanon Avenue. In 1920, the Borns sold out to Columbia Manufacturing Co. Pictured is a Crescent Grinder from 1895.

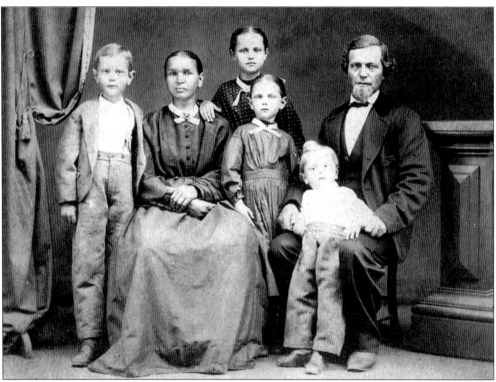

Edward Ebner was a working man. Born in Belleville in 1868 and apprenticed as a moulder at age 16, he learned his trade working in the foundries of New York and St. Louis. He established Illinois Foundry at Belleville in 1910 and his business took him to every part of the United States. He is pictured here as the youngest child of Anthony and Cresentia, miners and coal dealers of West Belleville. To quote Edward Ebner, "To make a casting is a matter of scientific study and involves more than appears at first sight." His foundry specialized in mining machinery.

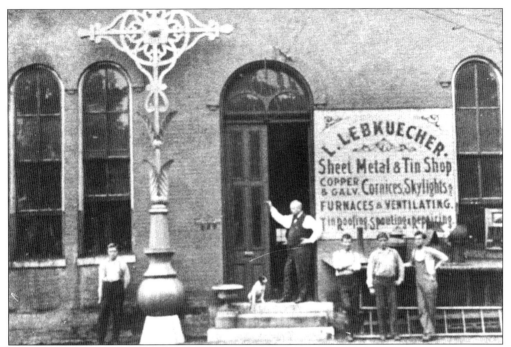

Leonard Lebkuecker (1851–1928), a tinner apprenticed at 15, opened his own business at 21. He manufactured metal cornices, ceilings, and sky lights and all manner of products in tin and terne plate. He semi-retired in 1890 by opening a manufacturing plant. Many of the crosses on church spires in the Belleville area were made by Lebkuecker. He also sold cast iron and tin body stoves. His shop with "STOVES" highlighted in the roof shingles can be seen on page 51.

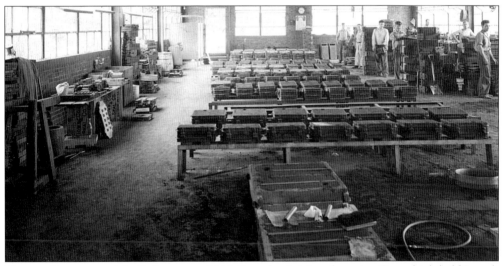

Century Brass was originally known as M.H. Foundry & Manufacturing Co., which held Joseph P. Heeney's 1910 patent on the sanitary drinking fountain. Heeney, the company's general manager, was a pioneer in the invention and manufacture of bubbling drinking fountains, soil pipe fittings, and combined traps. A downtown Belleville traffic accident ended his life and a rewarding, profitable manufacturing career based on his inventions. The company went into receivership and was subjected to lawsuits, but has survived to this day as Century Brass.

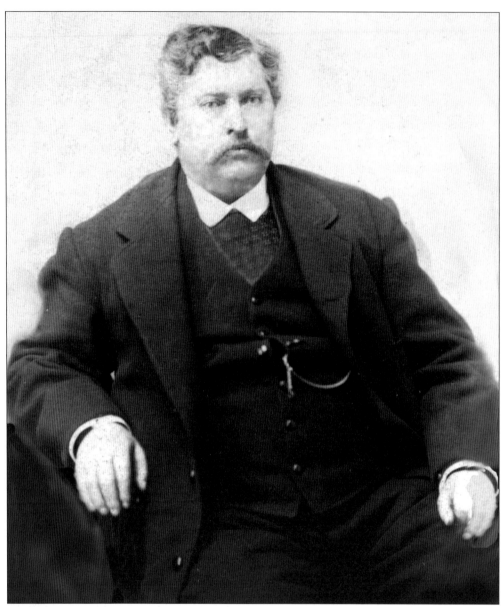

Bernhard Yoch is conspicuous among pioneers of St. Clair County coal mining. His family emigrated to Belleville in 1847 and farmed 320 acres in West Belleville, between South Twenty-ninth and Route 13 for 10 years before moving into coal mining. Christian Yoch and his three sons established one of the largest individually owned fields within the 50-mile radius of St. Louis. Three hundred to four hundred men worked the 15 Yoch mines. Bernhard, a machinist, patentee, and capitalist in 1876, received his first patent for a portable engine. The "Iron Man" was used for drilling coal. The "B-Yoch" self-propelling road engine followed. One of the many interests built up by the Yochs was a transfer boat used to haul coal across the Mississippi River. It was the ferry operation that attracted Jay Gould to the Yoch Mines, which Gould's syndicate purchased in 1886. Yoch had the funds and the coal to move Belleville into steel, wire, and cut nail production. His death in 1898, just when the country was recovering from the 1893–1898 nationwide shutdown, was most untimely.

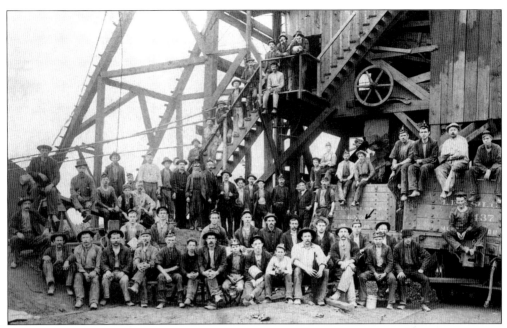

The Muren Mine, located one-and-one-half miles northeast of Belleville on the Muren Farm was sunk in 1897. The mine employed 200 men and had an output of 800 tons a day, making it one of the largest mines in the area. Lawrence Muren and his brother, John, were also stockholders in the J.H. Muren Mercantile Company of St. Louis and the Crescent Nail Mill at Belleville. In 1905, Southern Coal, Coke & Mining Co. leased the coal rights, but purchased the entire mine in 1932. In 1940, about 50 miners who worked without pay for a month became part owners.

Ellen Green was born to a long line of English coal miners and iron workers in 1844. She married Charles Nesbitt Sr., a charter member of the United Mine Workers in 1862. She was compassionate about her family, who dug coal in dark nightmarish conditions. As a young married woman, she scoured Belleville's small hand-operated coal banks for every bit of coal she could find to keep her family warm. Coal miner wages were $1.50 per day in 1876 and $1.75 per day in 1884. Her husband became president of the Trade & Labor Assembly in 1886.

The United Mine Workers sent an impressive delegation from Belleville to a 1905 Chicago meeting regarding the formation of a New Industrial Union. At front left is John Green, an immigrant from England, who led the movement to form the first miners union in America at West Belleville in 1861. At front right is Thomas Hitchings, who was born in the coal camps of Pittsburgh and became a charter member of Belleville Sub District 4. He held numerous labor and political positions during his mining career, including president of the Belleville Trades & Labor Assembly. At rear left is Edward J. Carbine, labor organizer and vice president of the Illinois State Federation of Labor. Carbine was also a charter member of UMWA and an International President. At center rear is Walter Nesbit. He served as a traveling auditor for the Illinois State Federation of Labor and was elected its president in 1930. Nesbit was a foe of John L. Lewis and it was at the 1929 State Convention at Belleville where the initial steps were taken to organize all coal miners into a national union. As a U.S. Congressman in 1932, Nesbit's main concern was the safety and well being of soft coal miners in Illinois. At rear right is Philip Sauer. Like Walter Nesbit and John Green, he followed a generational coal mining heritage. He was the son of a mine examiner and also a miner who rose through the ranks of the Belleville Trade & Labor Assembly and the Illinois State Federation of Labor.

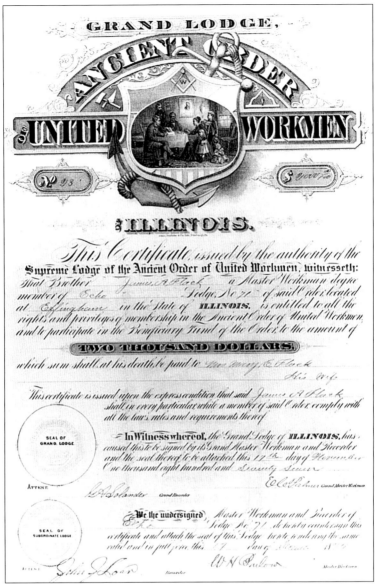

It would not be until after the close of the Civil War and the country moved into the industrial era that organizations like the Ancient Order of United Workmen would influence the lives of working men and women. The AOUW was founded on the "eternal truth" that "the interest of labor and capital are equal and should receive equal protection." Nationwide labor organizations such as the Knights of Labor and Knights of Honor had lodges at Belleville. The Workingmen's Benevolent Society was meeting regularly at the Republican House in 1860, and foreign-born workers especially pushed for and held a mass meeting of all laborers in 1878. Their idea was to form a national union. Between 1886 and 1891, Belleville workers hammered out the formation of a Trades & Labor Assembly as an independent central body. The original 12 unions expanded to 47 by 1913. George Flach, a retired Local 182 moulder and owner of Richland Foundry, led the first Labor Day Parade in 1895. The Flach family has a dedicated labor history which began with Belleville mason Conrad Flackenton in 1855. Pictured is the AOUW beneficiary certificate of James A. Flach.

When Solomon Mueller and his wife, Mary, retired from farming and cider distilling around 1886, they moved to 17 South Race Street (now South Third). The three-story, French Second Empire brick home had numerous mantels and fireplaces fashioned by Ehinger Brothers of Belleville.

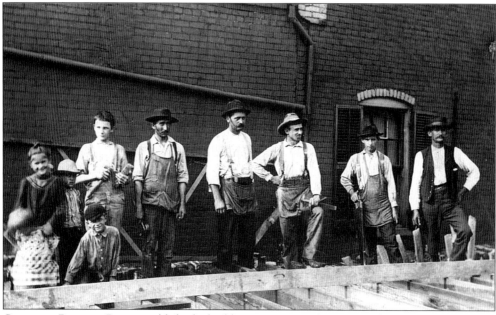

Carpenter Dominic Bauer established a building contracting business with Joseph Hilpert as his partner in 1893. Bauer Bros. was founded when Hilpert sold out to Dominic's brother, Casper. The firm successfully handled large contracts such as Scott Airfield Hangar, Oakland Foundry, BTHS's main building and boys gym, Central Junior High School, Elks Home, Belleville Shoe, and International Shoe. In 1912, the firm purchased the Ehinger Planing Mill on Lebanon Ave. Bauer Bros. provided steady employment for 25 to 30 union carpenters. The firm closed in 1989. Pictured is Joseph Hilpert, at extreme right, and next to him is Dominic Bauer.

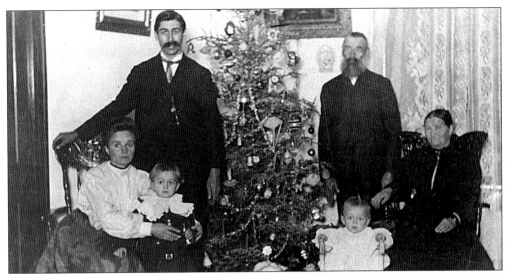

This three-generation photo of the Theodore Kaufhold family was taken at Christmas 1908 at the Bauer home, 2203 West Main Street. They are pictured with a beloved German tradition, a decorated fir tree and crèche. Theodore and Wilhemina are at right with their daughter Theresia, her husband Bermard Bauer, and their children, Bernard and Lawrence. Like many people of West Belleville, Kaufhold was a coal miner and Bernard worked as a moulder. At the age of 10, Theodore's son, Theodore, began a very brief career mining with his father. But through the intercession of Rev. A.J. Sauer of St. Mary's parish, Theodore was taken on at Kloess Contracting. When he retired, he was in charge of their finishing carpenters and supervised the construction of many of the beautiful staircases and woodwork found in downtown Belleville and country club residences.

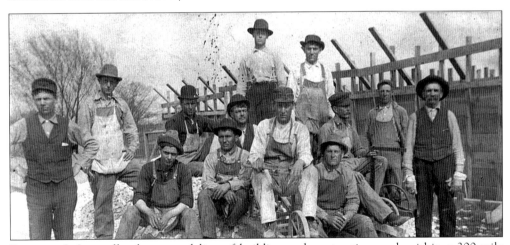

Bergman & Lutz offered a general line of building and contracting work within a 300-mile radius of Belleville. Neither were native-born Bellevillians, but came to Belleville from outlying areas to learn a trade. They established and incorporated Bergman & Lutz in 1904. Bergman is pictured at left and Lutz at right with 11 of their 45- to 50-person union carpenters building the first clubhouse of the St. Clair Country Club in 1911. Other projects included the Jefferson Grade School and Ideal Stencil's building and plant and the largest stove warehouse in the city for Orbon. The firm also operated a lumber yard in conjunction with their offices at Scheel and North Douglas.

Liese Lumber had a modest beginning when August Klotzbach founded the company in 1865. In 1872, his nephew, Julius Liese, acquired the yard. Julius also owned the Sucker State Drill Co. and secured a patent on a grain drill improvement with Andrew Schopp. Liese's first love was music. He played the kettledrums and piano. He was a music teacher and served as the second director of the Belleville Philharmonic from 1869 to 1885. He is pictured with his son, Walter, seated, and standing from left to right are Grover, Oscar, and Herman. Oscar and Walter took over Liese Lumber, Grover was an obstetrician in St. Louis, and Herman was an engineer and founder of Exploration Co. of Belleville, who died of typhoid fever out west.

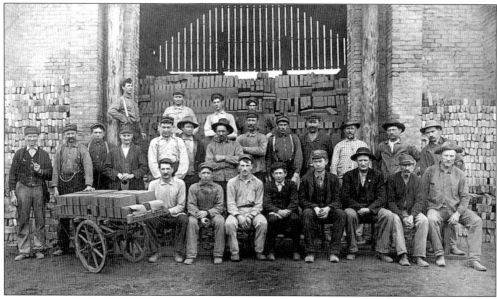

Handmade bricks of local clay made possible a tremendous building boom after the Civil War. By 1870, Belleville was a mature community with a well-built downtown and buildings, which depicted a well-established community and institutional life. Day Brickyard, established in 1881, became a giant with three locations covering a total of 90 acres of ground by 1901, when it was purchased by capitalists Edward and Ernest Abend and renamed Belleville Brick & Tile Co. The company, headquartered at 944 Freeburg Avenue, expanded again in 1913 when it purchased Standard Brick. Thirty-five million bricks were produced annually in 1914. The company was in business until 1945.

The Reis family initially settled in Belleville, but St. Louis and Minnesota attracted some members of the family. Joseph B. Reis, born in Shakopee, Minnesota, in 1862, became a successful contractor and lumber dealer in Belleville. Reis' father and sons built brick homes of grand proportion on South Illinois and South Charles Streets, plus Catholic diocesan and school buildings, the East St. Louis City Hall, and the FNB Building. In addition to banking, building, and loan activities, Joseph B. Reis had area-wide lumber interests as president of the Woodriver Lumber & Supply Co. and as a stockholder in the Carondelet Planing Mill in St. Louis.

The downtown residential beauty of South Illinois Street is beyond remembrance except in a couple instances. Pictured is the Theodore and Martha Karr residence at 326 South Illinois Street, built by J.B. Reis. Theodore and his brother, Adam Jr., expanded a leather business founded by their father, Adam, in 1839. Karr Supply Co. branched out into plumbing and heating and then Karr Range Co. Karr served in the Belleville Guard and capitalized People's Bank in 1879.

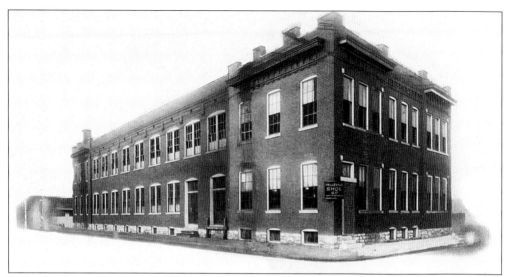

Belleville Shoe was incorporated in 1904 to produce boys high-top shoes. Pictured above is the second home of Belleville Shoe at East Main and Walnut Streets in 1913. Men's shoes were added to the production line in 1917 and military footwear in 1940. In the 1950s, contracts were gained for athletic shoes for such sports as baseball, football, track, and golf for Rawlings Sporting Goods in St. Louis. The company is owned by the Weidmann family and in its fourth generation of Weidmann management it is the largest producer of military footwear in the country. International Shoe, headquartered at St. Louis, also operated a McKay and Turn Factory in Belleville at 215–219 South First Street.

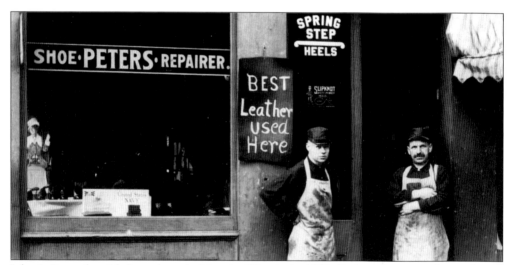

John J. Peters (at right) was born in Lincoln, Illinois, in 1873. Early in his career he made and repaired children's shoes at the Illinois State Children's Home. He came to Belleville as a young married man and opened a shoe repair shop in 1913. He was secretary of the Boot & Shoe Repairers Union from 1933 until he retired in 1945. He specialized in the precautionary boots required by moulders and miners. His son, Fred W. (at left), purchased the business at 130 West Main Street in addition to operating his own repair shop on Lebanon Avenue. In 1956, Fred's son, F. Walter, opened Peters Park Plaza Shoes at Forty-sixth and West Main Streets in Bellevue Plaza. The Peters family was in business repairing, making, and selling shoes until 1990.

Modern Machine Co. was founded by inventor George Remnschneider of St. Louis and then Belleville. Remnschneider came to Belleville because he wanted to manufacture a circular stencil machine and needed money and talent. In 1908, Modern Machine was manufacturing the Curtis Steel Die Embossing Presses and Sanitary Street Sweepers in Belleville. The stencil machine was in the future.

Remnschneider went on to become mayor of Belleville and in 1910 established Ideal Stencil. Modern was incorporated as Modern Die & Plate Press Mfg. Co. in 1912. It continues today as Chelar Tool & Die, industrial fabricators.

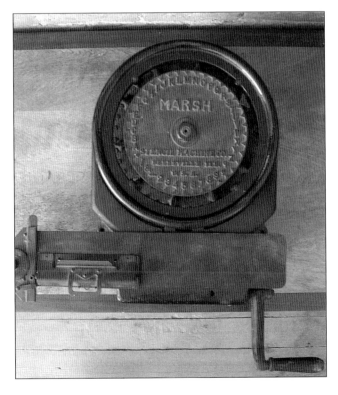

Got something to label and don't want to do it by hand, letter by letter? Get a stencil machine by Marsh! A family-owned business that grew to include ink, rollers, brushes, label makers, and tape machines for boxes began with a single product, the stencil machine pictured here. John W. Marsh, secretary/treasurer of Ideal Stencil in 1910, went on to found Marsh Stencil. Also an inventor, he propelled his company into national and international business. Twenty years ago, the company realized $17 million in sales and employed 200 men. In 1998, Marsh was sold to Marconi.

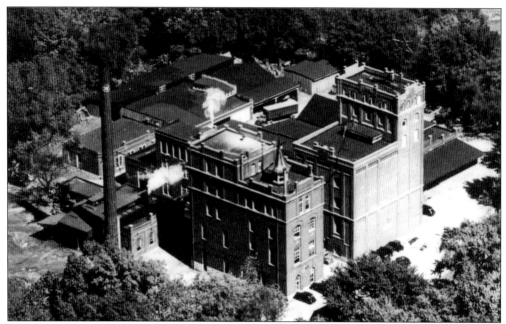

By 1874, the Star-Peerless Brewery included a three-story main building, an ice house, a cooperage, and a blacksmith shop. The cellar consisted of four rows of double arches containing nineteen vaults with thirty-four 50-barrel fermenting tubs. There were six lower cellars with the entire length over 500 feet wide and 13 feet high. Two large ponds furnished water. Prior to refrigeration, all beer needed to be delivered promptly, and in 1874 1,200 barrels per month were delivered as far as a team of horses could go in a day. Star-Peerless Brewery, at 1125 Lebanon Avenue, closed in 1954. St. Teresa Church now occupies the site.

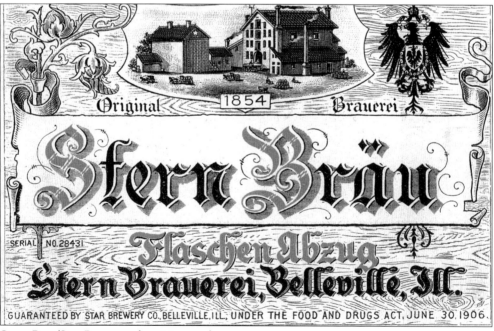

Stern Brau/Star Brewery advertising card.

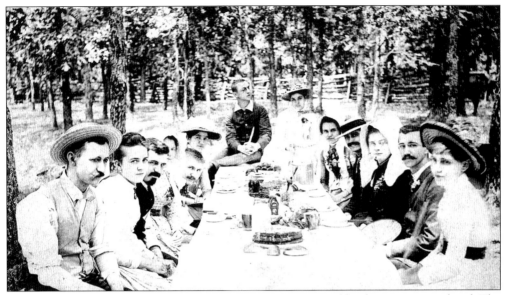

In 1901, Star Brewery operated a 21-acre park, which was served by the Air Line Railroad. The railroad terminated in the park. According to the cover of the 1901 Belleville City Directory, "The park had forests, lakes, and all modern improvements to accommodate thousands of people." The ad also asked the public to "try our Cabinet in bottles."

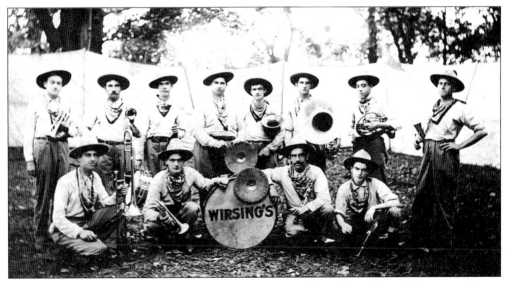

Otto K. Wirsing, a native Bellevillian and musician was elected president of Musicians Union 29 A.F.M. in 1903. As a successful band organizer, he was rewarded when one of his local bands was honored with the designation, "Illinois State Band." Wirsing taught violin and trombone, and for a time traveled with Buffalo Bill's Wild West Band. Wirsing's band is shown here, about to perform at Star Brewery Park.

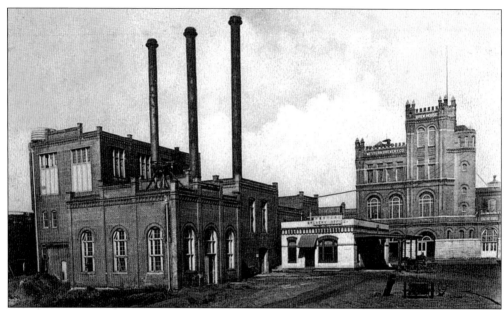

Griesedieck-Western Brewery, at Twelfth and West "E," was established in 1851 as Neu & Gintz. In 1907, Western Brewery sponsored a contest to name a new beer that would be marketed in the Belleville Area. George Wuller of Belleville submitted the winning entry, "Stag," and was paid $25 in gold. Stag beer became synonymous with Belleville, attaining top sales in the St. Louis metropolitan area in the late 1940s and 1950s. Stag was advertised as "pure, clean, wholesome and healthful . . . the product of a life study of brewing a light, clear, sparkling and nourishing beverage for every season." The brewery closed in 1988, but Stag is still available.

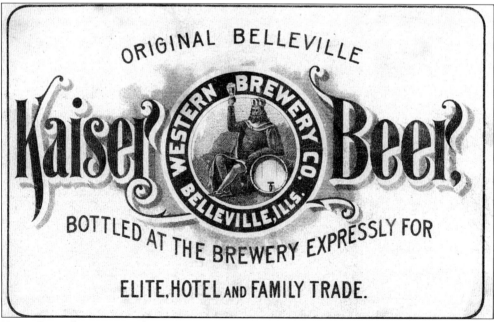

Kaiser Beer advertising card. Kaiser Beer predated Stag by only 10 years.

Washington Theatre, at 214–16–18 West Main, opened in 1913. An "Airdome," or open-area theatre, with a concrete stage was added in 1915. Owners offered a seating capacity of 3,000 with popular amusement resort shows every night, rain or shine. The theatre boasted the best in vaudeville and photo features. An ad proclaimed that only union orchestras and union operators and stagehands were employed.

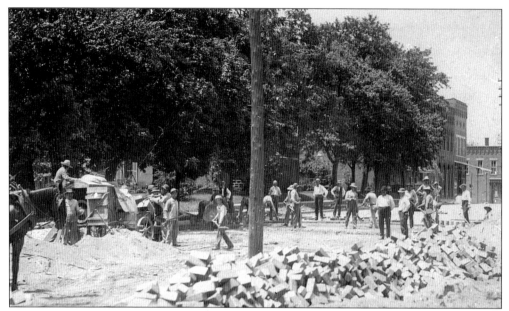

City roads were dust, mud, and garbage until 1850, when a cover of crushed rock was put down on main thoroughfares. In 1877, East Main Street was paved to Walnut Street with cedar blocks. Bricks replaced wood on East and West Main Streets beginning in 1898. Reeb Bros. workmen are shown laying 10-pound street pavers, paid for by property-owner assessment. By 1910, one could travel anywhere downtown without getting stuck. Reeb Bros., established in 1892, employed 150 men and used 25 to 30 teams completing large contracts in municipal work throughout Southern Illinois.

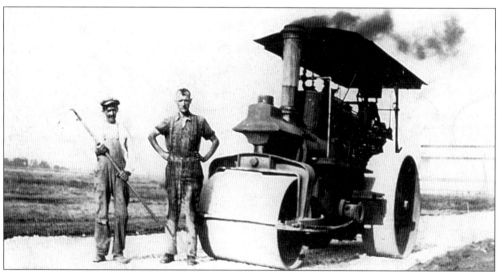

William Grandcolas, a machinist for Harrison Machine Works, was elected the city boiler inspector in 1903. The office was created in 1883 to inspect all steam boilers within the city limits twice a year. The fee was $2.50 per inspection. In 1904, the office was consolidated with that of the steamroller operator and in 1906 with the superintendent of streets. Grandcolas continued to serve as superintendent of streets. Hot water boilers generally replaced steam boilers in residential property shortly after the turn of the century.

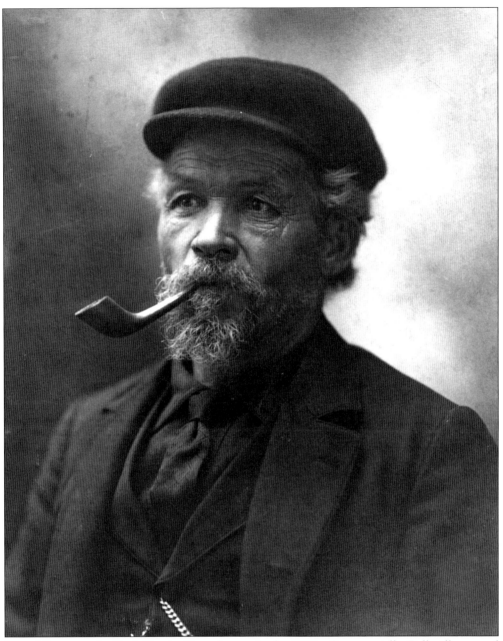

Louis Miyar was the Rock Road tollgate keeper in the 1880s. Commercially, Belleville wanted to be on the banks of the Mississippi River. In 1847, the St. Clair County Turnpike Co. built the "Rock Road." In 1850, it stretched from the Mississippi River to the Bluffs. Two years later, it was at High Street in downtown Belleville. The total cost was $128,000 and it was a toll road. In 1902, the State of Illinois banned toll roads and the tollgates were removed. Bicycle tolls were 5¢, one-horse vehicles 20¢, and two-horse vehicles 30¢.

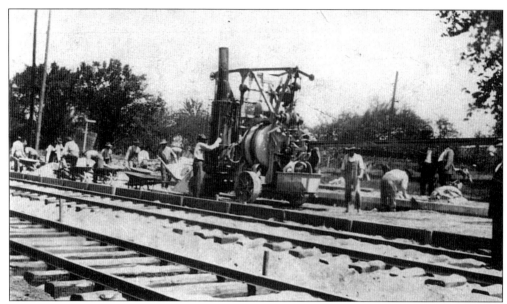

Hoeffken Bros., founded in 1892, is most famous for the Route 66 road and bridge work the company accomplished when that famous highway was constructed from Chicago through the American west. Pictured is the paving of outer West Main Street in Belleville in March 1908. When Main Street was paved, trolley tracks were moved to the center of the roadbed.

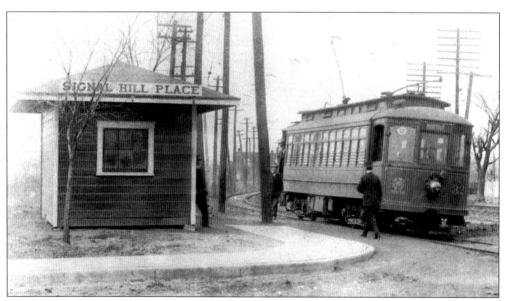

Newfangled electric trolley cars were an obsession in Belleville! The 1919 Centennial History of Illinois, Vol. V, reports Belleville had the first electric rail line in Illinois in 1899. The St. Louis, Belleville & Suburban Rail Road consisted of 10.5 miles of track and left from the Public Square. It was later expanded south to Walnut Hill Cemetery and east to the Oakland Addition. Pictured is the Signal Hill Station at West Main and Ninety-eighth Street.

Settlements along Rock Road can be found on early maps as "stations." The David Ogle farm, known as Ogle Station, was on Rock Road at North Seventy-fourth Street. The tract of land covered 32,000 acres and extended almost to O'Fallon. Pictured are the children of David and Margaret Ogle; the photo was taken around 1890. David's father, Samuel, served as a road commissioner and in 1838 was elected to the St. Clair County Board. David's brother, Joseph, served as an assistant surveyor under John Messinger and in 1851 was involved in the construction of the Belleville/St. Louis turnpike. He was also director of the Belleville Mail Line, the East St. Louis & Carondelet Railroad, and the American Bottoms Board of Improvement. The Ogle family emigrated to Illinois in 1818 from Newcastle, Delaware.

George Daiber was a well-known pretzel maker. He came to America as a youth and learned the baking trade at Baumann and Merck bakeries in Belleville. At the turn of the century, Daiber also had an animal menagerie at 5200 Rock Road, which attracted many visitors. On October 18, 1906, the name Rock Road was officially changed to West Main Street.

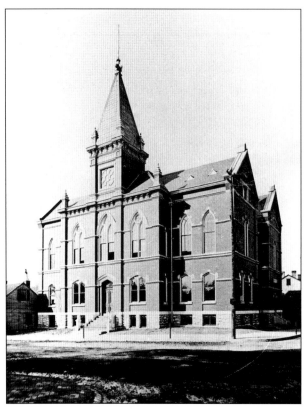

By 1890, the population of Belleville had increased to 13,361 and a larger city hall was drastically needed. The city council agreed to remove city government offices from the Market Square to South Illinois and West Washington Streets. The Belleville Public Library was to occupy the second floor—pictured is the reading room. In 1836, Dr. Anton Schott, a German Latin Farmer degreed in theology and philosophy, gathered 16 educated new comers and founded the first circulating library in the State of Illinois. The Belleville Public Library began as the German Library of St. Clair County and its collection of 346 volumes is part of the library's archives. The seeds planted by the Latin Farmers grew to become the Carnegie Library, built in 1916 at 121 East Washington Street.

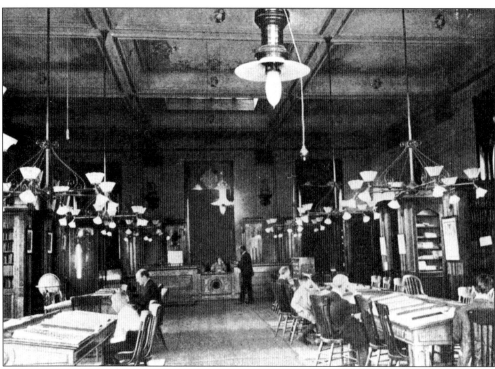

William Nebgen (1855–1923) emigrated with his mother, three brothers, and a sister from Prussia in 1865. Before embarking on a 30-year public service career, Nebgen was a carpenter. Locally, he was elected fire chief and served from 1891 to 1902. He served as police chief from 1904 to 1914. At the state level, he was still involved in law enforcement. He was a guard at the State Treasury and industrial foreman at Menard State Hospital and the Hospital for the Criminally Insane. Nebgen retired about 1920 and died at Belleville in 1923.

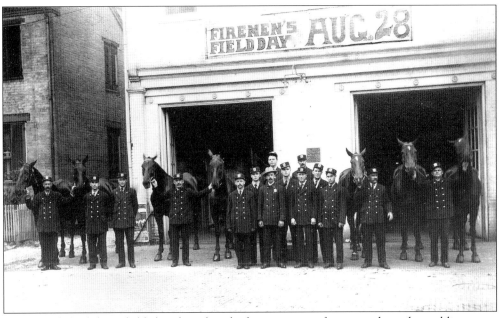

An annual firefighter field day drew hundreds to our city for a parade and a public square demonstration of the latest in firefighting equipment. In 1886, firemen received $10 per month wages, $5 for the first hour fighting fires, and $2 for each additional hour. In 1916, the city purchased its first motorized pumping unit.

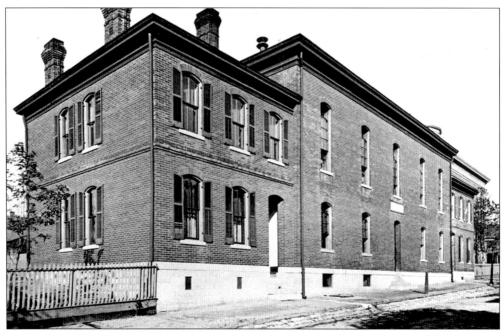

After prisoner escapes in 1868, 1869, and 1872, public agitation forced construction of a new St. Clair County jail. By 1885, this building was constructed on the site of the former Anderson Brewery at 19 West Washington Street. The chief jailer and his family lived on site. About 1926, a portion of the building settled into the abandoned beer cellars, forcing repairs. In 1971, these quarters were abandoned.

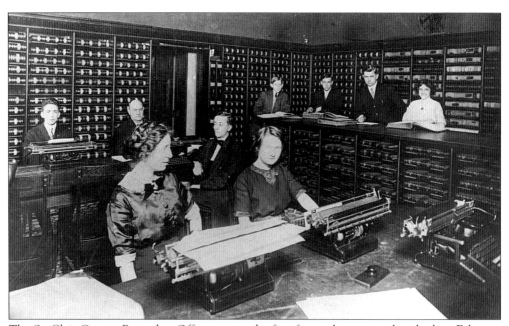

The St. Clair County Recorders Office reports the first farm sale on record took place February 5, 1793. A 400-acre tract was sold to Philip Engel for $120. In 1881, the land was subdivided into seven tracts and its estimated value was at least $22,000.

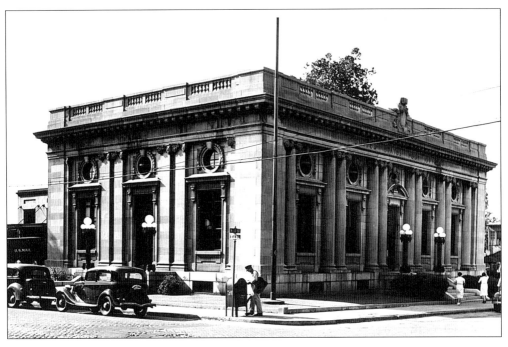

Until 1911, when this $100,000 U.S. Post Office was dedicated at West A and North First Streets, the post office was on the Public Square. The history of organized mail delivery began with the Great Western Mail Route which traveled the National Road. When mail was moved by railroad, delivery was more assured. It took only 24 hours for mail to move between New York and Chicago. Free mail service to Belleville homes was initiated July 1, 1887, and rural free delivery in 1896. Pictured below are the Belleville mail carriers in 1901. The National Association of Letter Carriers was organized in 1891 and this photo was culled from the six-page program for a Masquerade Ball sponsored by NALC in 1901.

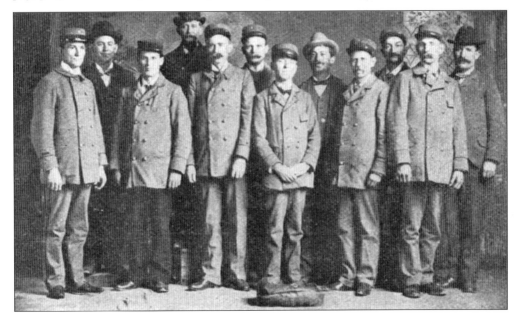

The First National Bank of Belleville was founded in 1874 and the first three presidents, Dr. Julius Kohl, Joseph Fuess, and Casimer Andel, were born in Germany. In 1896, the bank building pictured here was built on the Public Square by contractors J.B. and Val Reis. In 1900, stockholders voted to increase capital stock to $200,000, allowing the bank to circulate $100,000 in additional bank notes. Belleville and St. Clair County prospered. In 1914, the bank became a U.S. Depository Bank, which allows local U.S. revenue office and post office deposits. Pictured below at right is cashier Philip Gass, who was elected president in 1937.

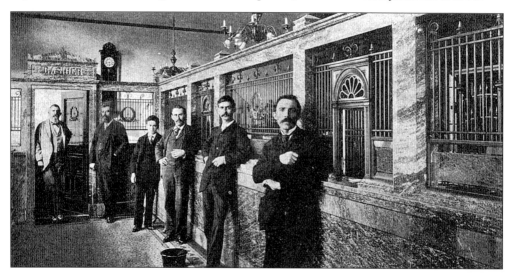

Peter J. Kaercher is pictured as a Grand Knight, Tancred Commandery No. 50, Knights Templar, York Rite Masonry. Kaercher initially joined the St. Clair Lodge No. 24 A.F. & A.M., which was founded at Belleville in 1842. Kaercher was born in Worms, Germany, but after serving in the Civil War he returned to Belleville and took over the *Stern des Western* newspaper. He also invested in a book binding and stationery firm and operated a saloon. In 1884, he was appointed a director of Belleville Savings Bank. He also served as president of the bank and chairman of the board. He was buried with full Masonic ceremonies in 1932. The banking community eulogized Kaercher as the dean of banking in Southern Illinois.

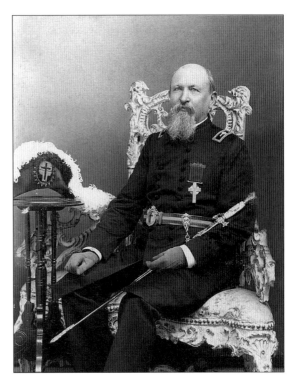

Belleville Savings Bank was established February 20, 1859, under a special fifty-year charter granted by the Illinois Legislature. The only other bank in the city was a private bank owned by Russell Hinckley of Belleville's Hinckley milling family. Belleville Savings is regarded as the third oldest bank in the State of Illinois and was originally named St. Clair Savings and Insurance Co. The interior of the bank at 21 East Main is pictured at the time of its merger with Belleville National in 1957.

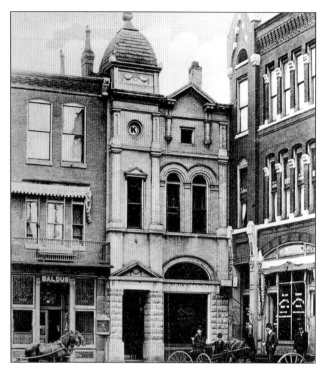

Belleville Bank and Trust Co. was organized in 1903 with $150,000. It was capitalized by Bellevillians Adam Karr and William Bender Jr., along with a group of St. Louis and Carlyle, Illinois, investors. Two years later, a 100-pound steel bell was installed as a burglar alarm to guard the assets. In 1921, the bank moved to a former post office location at the northeast corner of the Public Square. One hundred thousand dollars was spent to reface the building with impervious stone.

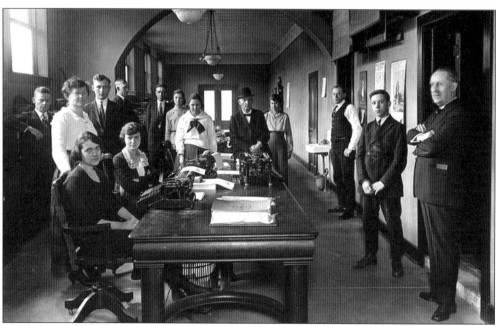

St. Clair Title was established in 1862 with offices in the basement of the St. Clair County Courthouse. The officers of the company are pictured here, Henry C.G. Schrader, at extreme right, and Elmer Arnold, next to him. Staff members are not identified. Schrader's abstracting career began in 1884 when he worked for $8 a month. In 1918, he instigated the merger of three local title companies into St. Clair Title. He served as president from 1918 to 1953. Elmer Arnold retired with 50 years service in 1987.

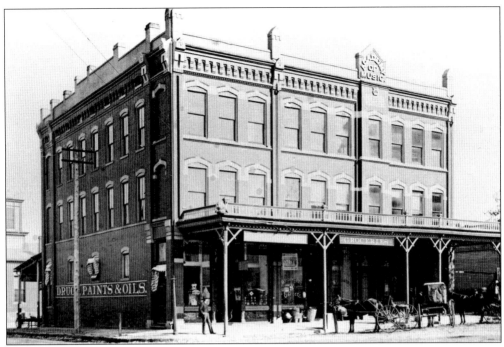

Benjamin J. West Sr. (1812–1912) was an active businessman and incorporator of diverse projects such as silver mining, deep well-water pumping, real estate development, and railroad building. He was a firm believer in the future prospects of downtown Belleville. West's Academy of Music was part of a city block of buildings he built for commercial use. The building's third floor had a seating capacity of 500, which was expanded in 800 in 1882 to meet the requirements of his main tenant, The Royal Order of the Elk. In 1915, when West's estate was settled, the Knights of Columbus purchased the building. Drugs, dry goods, hardware, and groceries were sold at the street level.

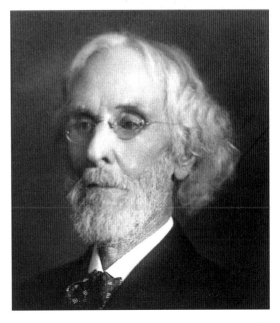

Benjamin J. West Sr. *c.* 1900. Photo courtesy of the Griffin family archives.

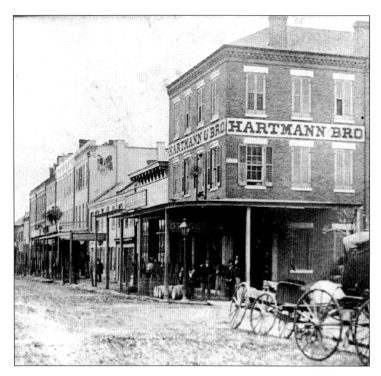

This is the corner of East Main and South Jackson Streets in 1865. Hartmann & Bro., enterprising young men from Hanover, Germany, were selling groceries and provisions, wholesale and retail. They advertised the best brands of coffee, tea, and tobacco, plus woodenware, tin ware, and fruit jars. Bernhardt and Hubert Hartmann gave up the provisioning business when they purchased Loesser's Brewery on Lebanon Avenue in 1868, one of the oldest breweries in Belleville, and renamed it Star.

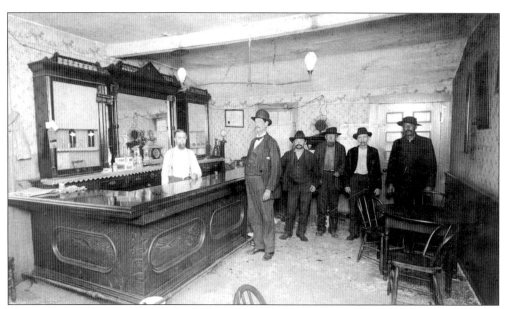

The 100-year-old Westrich Saloon at 15 East A is now a parking lot. It was demolished in 1937. John Westrich, a Civil War veteran, lived there with his family and also conducted a saloon. He came to America with his parents in 1854. The saloon is furnished in the European tradition—a standup bar available for a single drink after work and a place to get a free lunch on Saturday. An innovation was the tavern with a room at the back for the ladies.

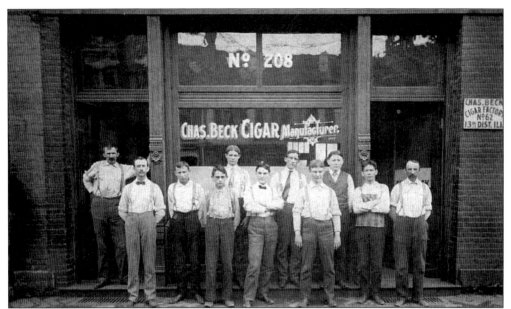

Beck Cigar was moved from 208–210 West Main Street to 123 North Church Street in 1913. The Becks began rolling cigars in 1901, and they were tinkerers. Charles "Sonny" Beck made to his specifications an oven and humidor used for his tobacco manufactory. The zinc-lined 43-inch by 72-inch drying oven remains in the basement of the Labor & Industry Museum. When Beck installed a contraption of his own making to strip tobacco, his cigar rollers walked out. Cigar rollers could not tolerate any type of machine that would take away a man's job.

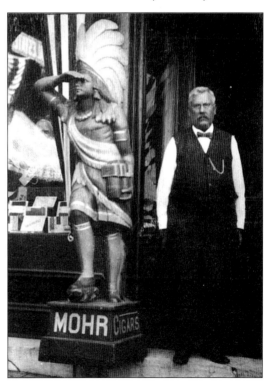

Tobacconist, Peter Mohr, is pictured at his shop at 24 Public Square. Mohr succeeded Martin Henkemeyer in 1891 and continued to roll the famous "Henkemeyer," a club-shaped cigar which revolutionized cigar making in this region. In 1883, Belleville was the largest producer in the Southern Illinois Cigar Revenue District, with 18 cigar shops rolling almost 3 million cigars annually.

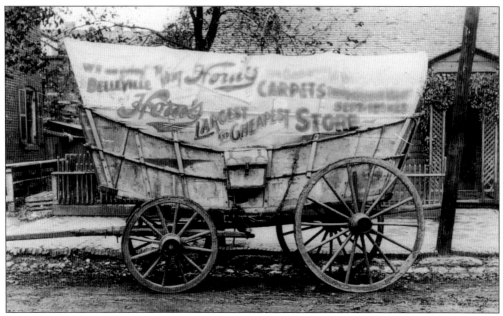

Adolph Horn came to Belleville in 1880 and opened Horn's Dry Goods in 1895 at 205–211 East Main. He used a covered wagon for advertising—one side printed in English and the other in German to promote his "immense assortment of dress goods, silks, white goods, linens plus an extensive line of ready-to-wear for ladies, jackets, capes, wrappers, dressing sacques and fur goods."

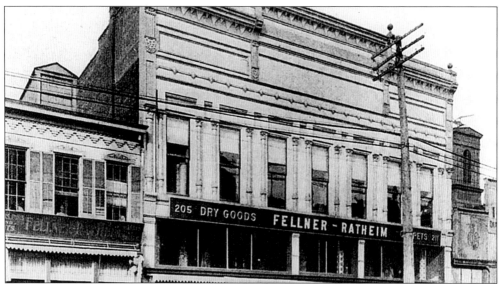

By 1900, Peter Fellner and Paul Ratheim had purchased interest in Horn Dry Goods on East Main and within a few years Fellner-Ratheim Clothing Store became the successor. The partners purchased a nearby property and expanded the store in 1909 to include household furnishings. They also opened a Fellner & Crow in East St. Louis. Fellner, Ratheim, and others purchased the county fairgrounds in 1912. Fellner also was an incorporator of a light, power, and heat distributing plant in 1908 and St. Clair Hosiery Mills in 1912. Fellner-Ratheim employed 30 people in this period.

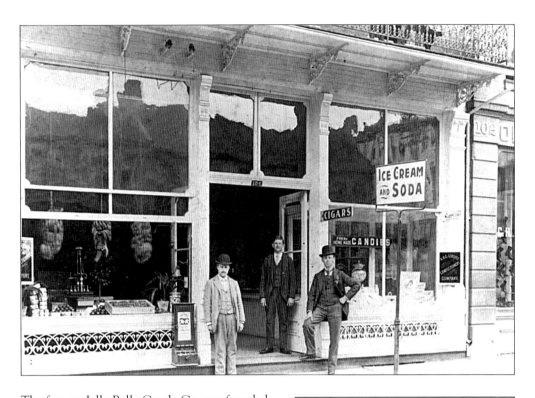

The famous Jelly Belly Candy Co. was founded in Belleville by two German candy makers in 1868. Albert and Gustave Goelitz made stick and sugar candy, which was sold locally. Albert peddled throughout the area in a horse and buggy until his death in 1880. Under the name Goelitz Confections, Gustave's two sons and their families manufactured an increasing number of gourmet candies in Cincinnati, North Chicago, and Fairfield, California. One hundred and fifty year-round and seasonal confections were made until what was to became the company's best seller, the natural-flavored Jelly Belly, was introduced in 1976. In honor of this famous candy, the company was renamed Jelly Belly Candy Co. in 2001. It comes in 50 flavors to be savored one at a time!

Miss Elizabeth Deimling, clerked at A.G. Confections at 121 East Main Street in 1896.

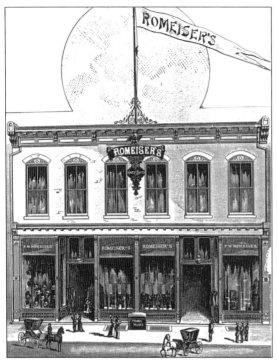

Peter Romeiser emigrated from Hesse, Germany, in 1873 and gained employment in a clothing store. Five years later, he acquired Alf Mayer's Pool Room & Pawnbroker establishment near High and Main Streets. His business, called St. Clair Clothiers, sold clothing, hats, furnishings, and goods. Romeiser wanted to be "on the cutting edge of his business." He was the first to install electric lights and, to the delight of his customers, the first to singly mark price tags. Expansions in 1886, 1898, and 1904–1905, meant that Romeisers nearly occupied an entire half block on East Main Street. P.M. Romeiser Clothing Co. closed in 1945.

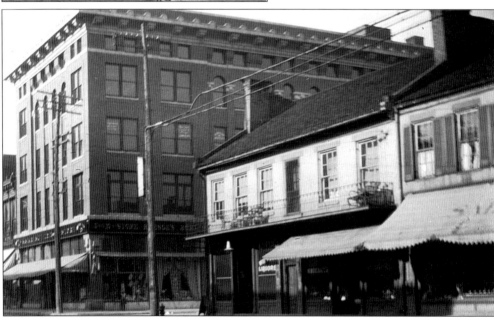

The Commercial Building was constructed in 1910 on the site of the 1854 Thomas House Hotel. Financial disagreements affected the ownership of the building, but not the occupancy. By the 1920s a number of professional offices were renting space. Southwestern Bell Telephone Co. on the first floor and Belleville Security Building & Loan, doctor, dentist, oculist, lawyer, real estate offices, beauty shops, and the Metropolitan Life Insurance Co. were on the second and third floors. A Masonic Lodge rented the fourth floor. The Mansion House is pictured in the foreground.

Joseph Leber emigrated to America in 1903. After serving an apprenticeship in St. Louis, he worked as a tailor for Frank Sadorf, proprietor of The Paris Cleaners at 315 East Main Street. In 1919, Leber opened his own shop next door to The Paris and married Sadorf's employee, Anna Elizabeth Michel. Leber was in business on Main Street until 1940.

Get another season's wear out of last year's winter coat—dye it! "Everything which can be accomplished in the art of coloring clothes is to be found in the Paris Cleaning & Dye Works." Austrian immigrant, Frank Sadorf, opened his establishment in 1906 at 315 East Main Street with an off-site workshop at 946 Freeburg Avenue. Pictured from left to right are Anna Leber Sadorf, Laura Rodemich, Frank Sadorf and J.L. Baechle. The business was closed in 1950 by Sadorf's son, Mathew, when he became the president and business agent for Dry Cleaners and Laundry Workers Union Local 42.

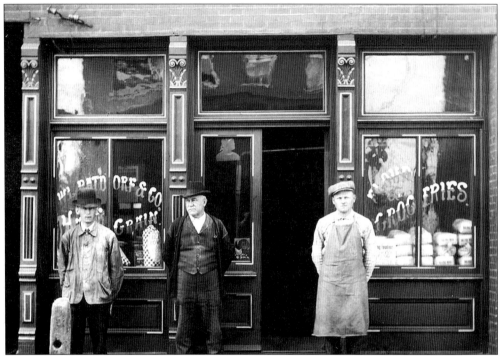

W.L. Batdorf & Co. was established in 1889. Batdorf and his two sons, Walter H. and William T., sold hay, straw, grain, flour, and feed both wholesale and retail at 126–130 West A Street. Batdorf was the local agent for Sleepy Eye and I.H. Flour. Farmers were guaranteed payment in cash. Batdorf Feed closed in 2004.

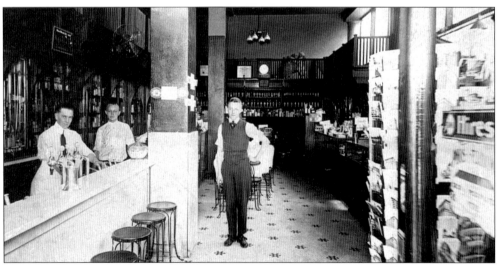

Julius Kohl made his way by working in a drug store. After earning a medical degree from Missouri Medical School he set up practice in Belleville and partnered in a drug store. He married and had 13 children. In 1882, his son Emil J. and George Ludwig purchased Dr. Kohl's interest, and another son, Arthur M., "acquired one of the most honored and extensive medical practices in Southern Illinois." The Kohl family served Belleville's pharmaceutical and medical needs for over 80 years. Al Arnold, an apprentice pharmacist, is pictured at the photo's center.

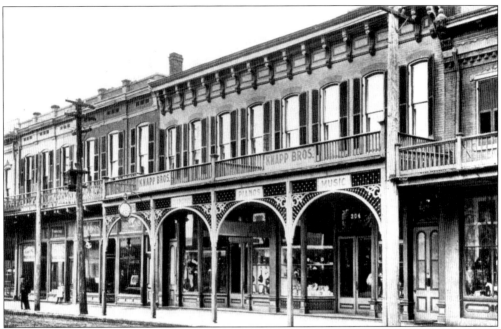

The Knapp Bros. store at 304 East Main seems to possess the efficiency and balance any businessman would desire in his accounting books. The clean lines of the windows balanced over the arches of the front porch make a solid impression. Phillip and Joseph Knapp began selling jewelry and musical items in 1891. Fifteen years later, they purchased the neighboring furniture business owned by Fred Aneshaensel and by 1910 expanded again to provide more space for furniture sales. The brothers had grown from their original spot at 310 to include 314 East Main.

Joseph Leopold, distiller and importer of old world wines and liquors, immigrated in 1858. His brother Edward followed in 1861. Together they purchased the Kellerman Bros. spirits business and renamed it Leopold Bros. Their overseas business office purchased many different brands of Schnapps, Blooming Valley, and Old Commission Rye, which they distilled in the name of Joseph Leopold & Bro. Edward's son, Irvin J., succeeded Henry J. Lengfelder as president of Orbon Stove in 1933.

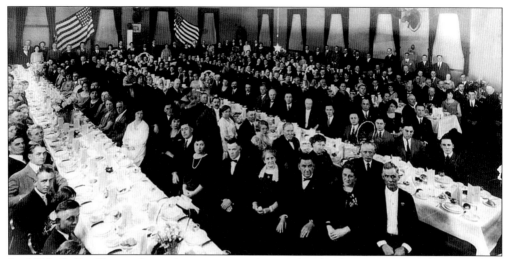

In 1898, Belleville retail merchants organized a credit check association. The merchants association was a member organization that added a collection bureau in 1928. The Retail Merchants Association operated Belleville's only credit bureau with the assistance of secretary and manager G.A.F. Schrader. In 1946, the assets were sold to Harry Boyd of Mascoutah, Illinois. Under Boyd's leadership, the Credit Bureau of Belleville became one of the top ranking credit bureaus in the state. Boyd also served as chairman of the National Credit Bureaus of America. New offices were built at 305 South Illinois in 1963. The bureau was sold to the Credit Bureau of St. Louis, Missouri, when Harry and Ethelyn Boyd retired in 1972.

Edward A Woelk, a cigar maker from Springfield, Missouri, met Alexander Graham Bell in 1877. He returned to Springfield and established a telephone exchange with 88 subscribers which he sold to the Bell Telephone Co. of Missouri. Bell sent Woelk to Belleville in 1882 to set up an exchange, which he did in the Penn Building on the Public Square. In 1895, the city installed about three phones in each ward for an annual fee of $25. Telephone service became confusing when Kinloch Company provided service in 1900 and people and businesses were compelled to have two lines. Woelk was also instrumental in establishing the Telephone Pioneers of America, an AT&T employee volunteer organization dedicated to community service.

In 1904, over 12 million visitors attended the St. Louis World's Fair. One of the fair's fondest admirers was Sam P. Hyde of Belleville. His hand-illustrated photo memoir, *Recollections of the Fair*, was assembled in 1909. Hyde, a bookkeeper, wrote his memoirs in calligraphy and also used snapshots. In 1996, the Missouri Historical Society published his memoirs *Indescribably Grand: Diaries and Letters from the 1904 World's Fair*.

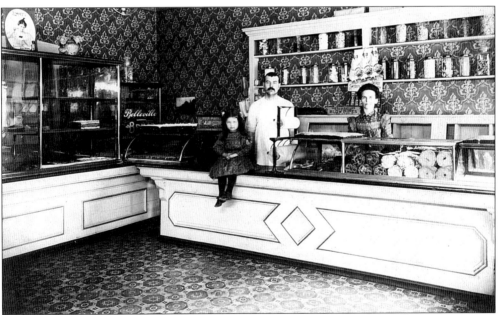

John N. Wilbret traveled as a baker working in Belleville, St. Louis, and Denver, Colorado, before settling in Belleville and opening Home Bakery on the Square at West Belleville. In 1905, he purchased property at 1007 West Main and installed a modern shop—it became the first electric bakery in the city. Wilbret was born in Alsace-Lorraine in 1876 and emigrated to America with his parents. He married and had two sons, both of whom became dentists. Their offices were in the second story of Home Bakery. Belleville's first bakery was Mercks in 1835.

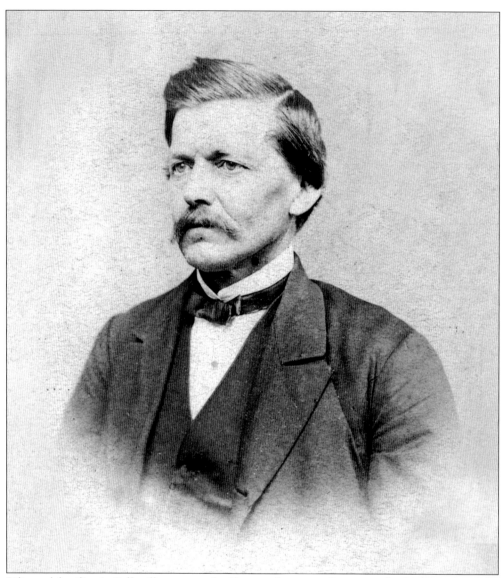

Bilingual families in Belleville supported a German Language Press into the 20th century. The *Belleville Zeitung* published a 50-year jubilee issue in 1899 and the *Belleviller Post & Zeitung* published a centennial issue in 1914. Franz Grimm, editor of the *P-Z* described Belleville as "the goal of the America-weary" in 1855. "Of all the thickly populated parts of the West, it is perhaps St. Clair County, and Belleville in particular, which offers all those living conditions that a German requires for his own well being. The very aspect of the city...the architecture...the abundance of breweries, distilleries and drinking places, the green vineyards and hops-gardens...vividly recall the old homeland. The Americans themselves remain more often in the background. In Belleville there are no 'Dutchmen' but only 'Germans.' Belleville is one of the few places where the German, without worrying about puritans, fanatical know-nothings, Sunday laws and slaveholders, can peacefully and with satisfaction drink his glass of lager beer, smoke his pipe and tell war stories...Sunday, which almost everywhere in the U.S. is dull, is in Belleville the day of recuperation that it should be. . . ."(Bergquest 1966:47–48). Grimm was killed in the Civil War at Pittsburg Landing in 1862.

George L. Hankammer began his career with partner Anselm L. Bedell in 1911, photographing the social and physical aspects of Belleville. Two years later, he was on his own in a career that spanned a time of great technological development in photography. He worked with glass plate and gelatin dry plates and finally sheet film negatives. He retired from his studio in the Twenhoefel Building to join Merker Studio in 1923. Hankammer's talent is evident throughout this publication.

Wherever Germans settled, there was music. It seems all children took music or singing lessons on Saturday. Franz and his son, Professor Edwin Mayr, conducted a music studio on East A Street for two generations, beginning in 1875. They were piano tuners and repairmen, music teachers and bandmasters. Edwin also served as vice president of the Musicians Union Local 29 and secretary of the Belleville Concert Band. Professor Mayr organized a 12-member band that played regularly at Eimer Park, then a military band in 1906, and lastly Mayr's Concert Band and Orchestra. He died "on the job" in 1929.

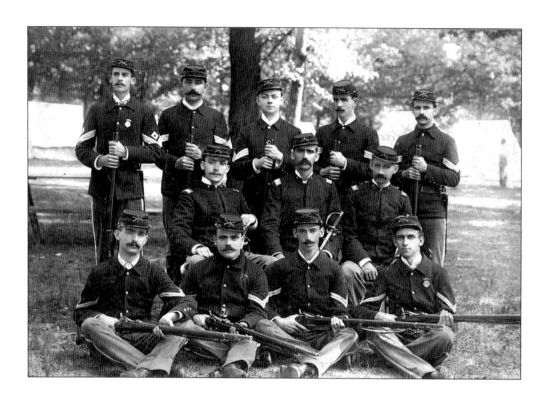

The Spanish-American War in 1898 ended Spain's rule of Cuba. Mobilization of military forces rested with volunteer drill companies, as universal military training did not exist in 1898. Col. Casimir Andel, a veteran of the Civil War, commanded Company D, 4th Illinois Volunteer Infantry. The 108 recruits were mustered into service at Camp Tanner, Springfield, Illinois on May 19, 1898. Pictured, from left to right, are as follows: (first row) Walter Fuess, Milo Hilgard, Charles Betz, and Fred Storck; (second row) Ferd J. Schrader, Eddy P. Rogers, and Charles Krebs; (third row) Edward Abend, Ben Gundlach, Hugo Goelitz, Ernst Abend, and Henry Rentchler. Company D formally disbanded May 26, 1899. Pictured below is an encampment of the Belleville Regiment, Spanish-American War, 1898.

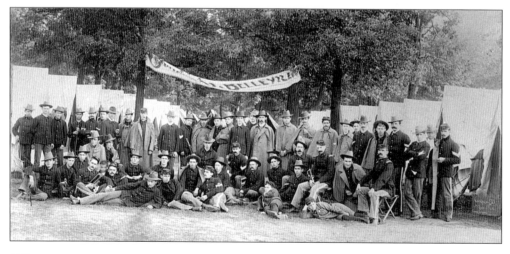

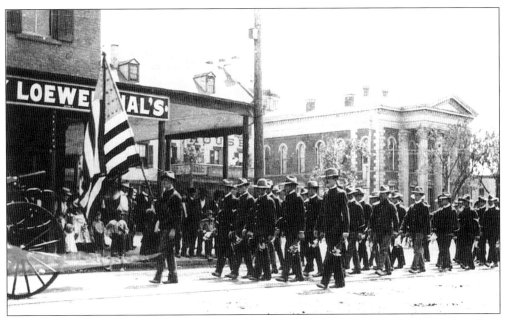

Decoration Day, now known as Memorial Day, was established in 1868 by the Grand Army of the Republic after the close of the Civil War. In 1872, Belleville's Memorial Day Association added a parade to the activities, a custom that continues to this day. Pictured are veterans of Company D, in military uniform, rounding the Public Square and heading down East Main Street, c. 1900.

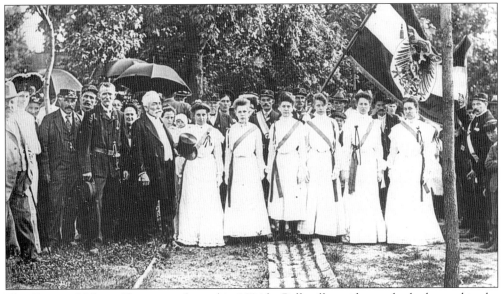

The German Military Verein was formed in 1894 by Belleville residents who had served in the German Army. Two years later, a national convention of similar units was held in Belleville. In 1898, William Wiemer was elected president; he is pictured at the right of the pole. The group apparently disbanded about the time of World War I, when pro-German sentiment was discouraged. German military companies were not unusual in Belleville. In 1859, the Belleville, Illinois, Yaegers was almost entirely composed of German natives.

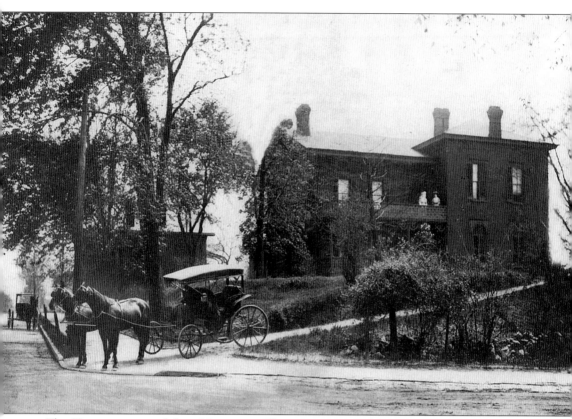

The Turners emigrated from Virginia to Illinois in 1830 and farmed near Freeburg, Illinois. After graduating from Washington University School of Law, Lucius Don Turner II moved to Belleville. He and R.D.W. Holder became partners with offices in the basement of the St. Clair County Courthouse. In 1890, Don Turner purchased the Hinckley residence, which occupied the 500 block of South Jackson Street. Hinkley was an early flour miller at Belleville and also operated a very successful private bank on the public square. During Turner's lengthy legal career, he also served as president of the Belleville Savings Bank, vice president of the Illinois Bankers Association, and as a public speaker he was in great demand. In 1912, he delivered the welcome address at the Illinois State Bankers Convention held at the St. Clair Country Club. Turner's interest in music prompted him to assist founding the Choral Symphony Society. He served as president from 1903 through 1907. The group performed at the 1904 St. Louis World's Fair and gained a medal of commendation. His son, L. Don III, established a law firm in East St. Louis, Illinois, but moved to Belleville and the Holder firm when his father died in 1918.

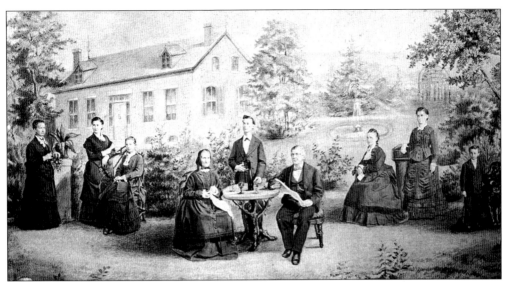

Joseph and Elizabeth Fischer pose with their children in this composite photograph taken on the lawn of their home at Mascoutah Avenue, c. 1870. Fischer, an Austrian immigrant, founded his soda water works in 1849 and was considered a pioneer in the industry. The works was purchased by his nephew, John Winkler, in 1882, who continued to manufacture soda water, seltzer, and ginger ale. His product line also included the difficult-to-get Sheboygan waters.

Brothers Anthony and Rev. David Badgley of Virginia came to St. Clair County in 1804 and settled on land adjoining Belleville. Anthony's grandson, Albert G., born in 1830, sold dry goods on Main Street in 1860, was a teller at People's Bank in 1877, and then became an attorney. But he made a fortune in coal. He built this French Second Empire home at 300 South Charles Street in 1876.

The Kronthal, home of Jacob Brosius, an inventor, industrialist, and community servant, was built in 1876 at 735 East Main Street. His estate extended three city blocks east. John Geiss and Jacob Brosius, blacksmiths, founded a machine shop in 1855 and began the manufacture of seeding machines, cider and wine mills, and iron railing. After earning six patents in improvements to agricultural equipment, he turned his interest to steam conducting pipes and radiators. In 1874, he devised and built a steam-powered heat-generating plant. Main Street businesses utilized his heat and radiators of his invention. He also founded Brosius Oil Works, a very successful oil works specializing in castor, linseed, and pecan oils. He died in 1882 at age 59.

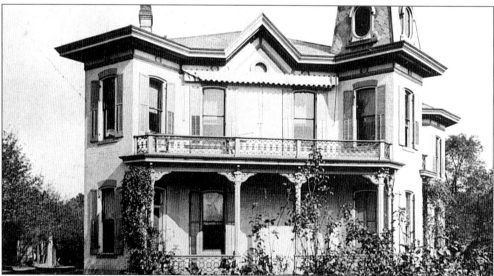

Henry A. Kircher, a Civil War veteran who lost his right arm and left leg still managed to run a hardware store and attain public office. When Kircher returned to Belleville, he entered politics and was elected clerk in 1864 and mayor in 1877. In addition to many company directorships, he also incorporated the City Water Works, Belleville Elevator & Warehouse Co., and the Gas Light & Coke Co. He incorporated Kircher & Sons Hardware in 1889, a company founded by his father, Joseph, in 1848. Interestingly enough, in 1897 Kircher built a lawn bowling alley at his home, 7 Kircher Place, intended for private use only.

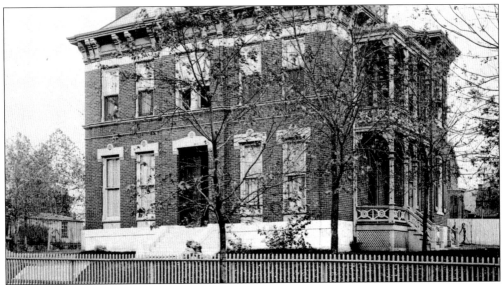

Bernhard Hartmann was born in 1841 and emigrated from Germany to Belleville in 1865. He exemplified the successful businessman of the last half of the 1800s. Hartmann and his brother, Hubert, owned Star Brewery, the present site of St. Teresa Catholic Church. Star brewed near beer and the real stuff. In 1922, government agents poured 1,000 barrels of beer down the sewer—a small fortune of 35,000 gallons. During the depression, Star sold ice. Hartmann capitalized smokestack industries; namely Hartmann, Hay & Reis Nail Mill, Belleville Distillery, and Sucker State Drill. He also became involved in the Belleville & Northeastern Railroad, Security Fire Insurance Co., and Belleville Safe Deposit. He died a millionaire in 1922.

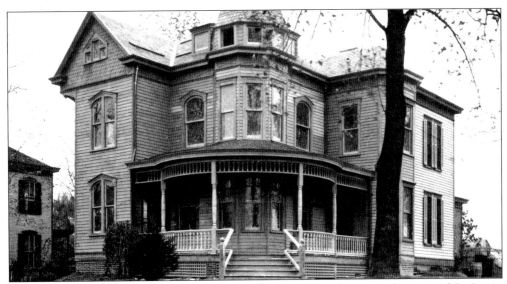

The Heinzelmans were prolific inventors. The buggy and carriage manufacturers of St. Louis, Missouri, established a branch factory at Belleville in 1858 at North Jackson and East "B" Streets. They specialized in the Timken Side Bar Buggy. Heinzelman Bros. moved into carriage manufacturing and eventually into kaupet auto tops with outlets in St. Louis and Denver. They were part of the Belleville business community for 80 years. William A. Heinzelman built this Queen Anne style home at 102 North Douglas, c. 1905.

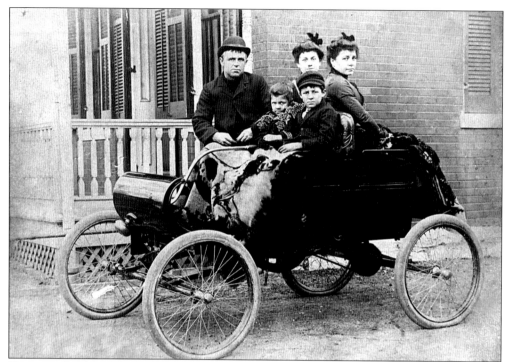

Henry Deobald, secretary of Belleville Brass Works, machinist, and auto builder, built the first Belleville steam-powered automobile pictured here. St. Louis auto dealers declared it the "best yet built." The first gas-powered automobile was built in 1901 by Charles Procasky and Edward Dobschuetz of Belleville. It featured a chain-type transmission with two speeds mounted on a body built by Heinzelman Carriage of Belleville. The two men drove their creation until manufactured cars came to town. The first factory built car in Belleville was a 1902 Oldsmobile driven by Jacob Wainwright of Belleville.

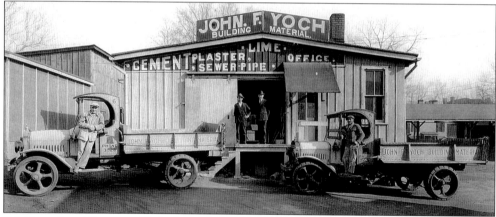

Bricklayer Local 2 was established in 1886 at the offices of Fred Daab Lime & Cement Co. The number "2" indicates the second bricklayers union in the State of Illinois. At that time, bricklayers earned 45¢ per hour. Daab founded his company at 700 South Illinois in 1867 to sell German and English cement, lime, and sand. John F. Yoch purchased and expanded Daab's company to include sewer pipe, limestone, and coal, but Yoch was most proud of his new "delivery carriages."

114

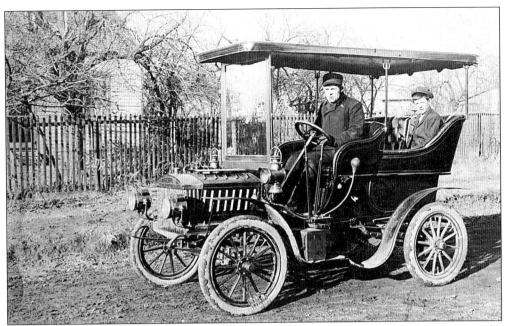

Jacob Wainwright Jr. had wheels—auto, motorcycle, bicycle. Jacob was a glass blower by trade, but operated the first taxi in Belleville and East St. Louis. His stunts put him in Ripley's Believe It Or Not. Jacob and his son, George, are pictured in a 1910 Sears Model H—the first taxi in Belleville. In 1905, the city council set maximum speeds: one mile in six minutes for congested areas, and one mile in four minutes elsewhere. By today's standards that would be 10 and 15 miles per hour. Children driving was outlawed in 1911.

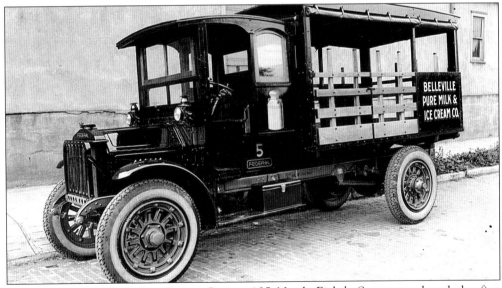

Belleville Pure Milk & Ice Cream Co., at 105 North Eighth Street, purchased the first automobile delivery wagon in Belleville. The company sold pasteurized bottled milk and cream plus 60 varieties of ice cream, sherbets, fruit ices, puddings, and brick, all flavors. Joseph Bier also made fancy forms of fruits and flowers at the company he founded in 1902 and in 1929 sold to St. Louis Dairy Co. for $65,000.

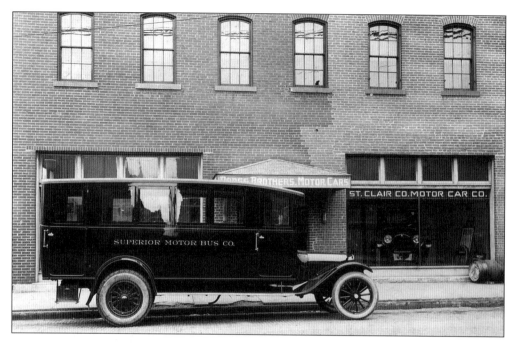

Oliver C. Joseph Chrysler Dodge is the country's oldest Chrysler Dodge franchise still operated by the original franchise holder. The agency, located at 223 West Main Street, was started in 1914 by Joseph, who had been manager of St. Clair Motor Company. A streetcar jumped the track in 1923, causing the damage pictured below. Before entering the automobile business, Joseph was a school teacher for six years in St. Clair County rural districts. In addition to his automobile business, Joseph liked to hunt and procured 100 acres of land north of O'Fallon, which he wished to make one of the most "delightful places for hunting pheasant, quail and fox, plus fishing."

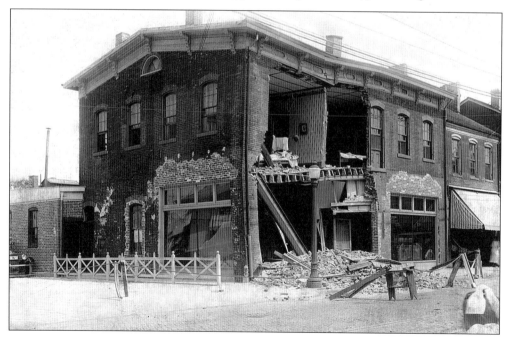

Herman G. Wangelin, postmaster of Belleville like his father and grandfather before him, left his post in 1948 to devote himself full time to an automobile business begun by his father in 1910. Modern Automobile & Garage Co. sold Ford and Lincoln autos at the corner of East Main Street and Mascoutah Avenue. Wangelin also ran an "automobile exchange and repair operation." When he died in 1973, he was regarded as the "Mayor of Main Street" for his civic service and leadership in Belleville. He led the drive to consolidate Belleville's Board of Trade and Belleville's Commercial Club into the Chamber of Commerce in 1925, and served as the organization's first president. He also served the chamber at the state level. During his term as president of the Grade School Board, four new schools were built and he also worked tirelessly for Rotary International.

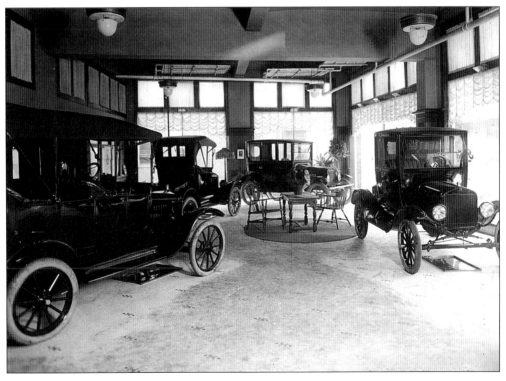

Carrie Bahrenberg (1861–1929) received national recognition for her social activism. She was the daughter of Col. John Thomas, a Belleville industrialist. At the age of 26, Carrie Alexander was widowed. She became secretary/treasurer and manager of the St. Louis, Belleville & Suburban Railway, a railway started by Daniel P. and Henry Alexander and documented as the first electric railway surface line in Illinois. Her activities in the Women's Relief Corp and the women's suffrage movement made her a close friend of Jane Addams, the famous Chicago suffragette. Bahrenberg was elected a University of Illinois trustee in 1900. She served 12 years. In 1915, she was elected the national president of the WRC. After the passage of the 19th Amendment in 1919, the Equal Suffrage Association of Illinois was renamed the Civic League. Bahrenberg was chairman.

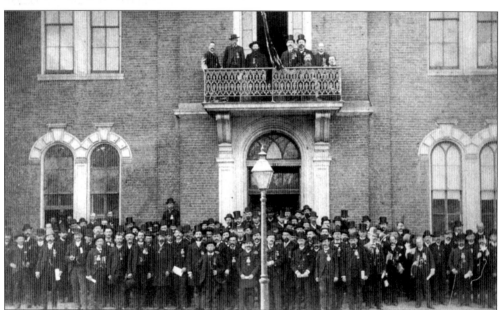

In 1888, the North American Saengerbund Festival was held at St. Louis, Missouri. This photo, taken at Belleville's Liederkranz Hall at 119 North Illinois Street, shows a portion of the festival goers. Possibly since Belleville was included in the festival, part of the program took place in our city. The Liederkranz was the largest singing society in Belleville. It's bylaws simply state, "The purpose is the rehearsal and perfection of singing as well as social entertainment." The Liederkranz Society sponsored a male chorus, a ladies' chorus, and a singing school for children. It disbanded in 1940.

Pictured are J. Hugo Magin and Lillie Dobschutz, costumed as George and Martha Washington. They are part of a children's choral group directed by Gustav Neubert in 1890.

As early as 1840, a local theatre organization presented a play at Squire Scott's home on Main Street. In 1878, the Thespian Club, an amateur dramatic organization for young men and women, was organized by Mrs. Charles Thomas and Mr. Ernest Hilgard. These children have not been identified.

Sophia Rhein (1884–1952), a popular and energetic woman in Belleville's singing society circles, was a graduate of Boston's New England Conservatory of Music. She conducted choirs in New York and Pennsylvania before returning to Belleville in 1908. "Something new and different" was her motto. She organized the Cecelia Chorus in 1911, pictured here. The members, from left to right, are Frieda Merck, Clara Rhein, Ella Hucke, Frieda Stephanie, Matilda Dapprich, unidentified, Sophia Rhein, and Matilda Heineman.

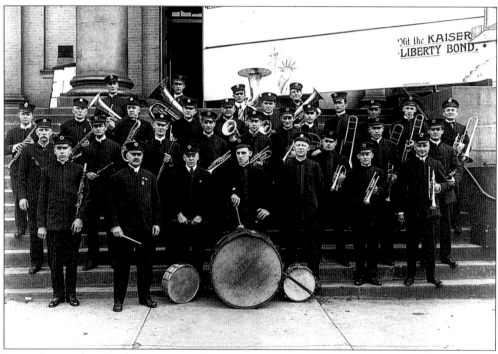

Festivals, parades, Sunday afternoon family park events, and celebrations of all kinds were enhanced by Belleville's bands, orchestras, quartets, and brass and reed bands. Liberty Bond parades were held regularly and U.S. Armed Forces volunteers were escorted to troop trains and depots by citizens and marching units during World War I. Pictured is the American Federation of Musicians Local No. 29 Concert Band, on the St. Clair County Courthouse steps ready to play for a "Hit the Kaiser Liberty Bond Rally."

Four

1914 Centennial

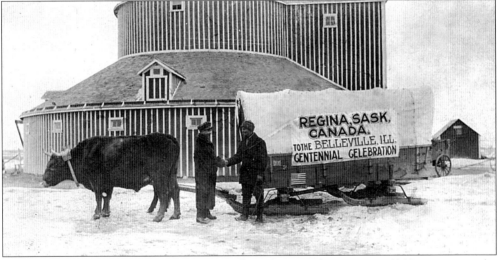

Bellevillian Charles Wasem moved to Canada and returned to town in 1914, promoting the Belleville centennial en route in a way P.T. Barnum would have judged first rate. His solo, 2,100-mile, oxen-drawn, schooner prairie odyssey stretched from Regina, Canada, to Belleville. He ate and slept in the wagon and suffered hearing loss from his ears freezing—recreating the pioneer spirit of Belleville's settlers. He covered most of the expenses of his trip by selling postcards and other items in each town he stopped in. Wasem feared one of his team was lame as they passed Collinsville, but the limping ox was able to finish the trip and at 10:45 a.m., September 12, 1914, Wasem and team were greeted by a crowd of 2,000 people at the public square. He had averaged one-and-one-half miles per hour. He told a Belleville news reporter, " I am not going to ride another mile behind oxen in all my life." Resuming a relatively stationary life in Belleville, he made his living painting movie posters for Washington and Lincoln theaters, and also covered his back yard with worm beds and seined local streams for minnows to sell in his bait shop. Might sound like a fish story, but it's true—a whale of a tale.

The week-long centennial celebration began with a sacred concert at Liederkranz Hall, but the highlight of the event was a three-night performance of a specially written pageant featuring 500 members of the community. The pageant, staged on Waterworks Hill on South Illinois Street opposite the County Fairgrounds, depicted the history of St. Clair County through the narration of an Indian Medicine Man, who "could use magical powers to conjure up the past." Some of the scenes are: early French explorers tell Indians of "their new white father;" George

Following the last performance of the pageant, a carnival performed with feats of daring—a man diving from a 100-foot high perch into a tub of water—and exotic animals, one bearing a mysterious woman we will call—not knowing her true name— "Camille on a camel." Police Chief Sam Stookey was on the lookout for mysterious looking visitors—grifters, pickpockets, con men—ordering 40 extra patrolmen and 15 more plain clothes cops to keep an eye on the expected week-long crowd of 30,000.

Rogers Clark takes the post of Kaskaskia while the French commandant gives a ball; county representatives bargaining with George Blair to locate the new county seat on his farm; Gustave Koerner faces down a mob and purchases the freedom of an African-American; Captain U.S. Grant swears in a company of St. Clair County volunteers; and East St. Louis conquers the flooding Mississippi under the leadership of Mayor John Bowman.

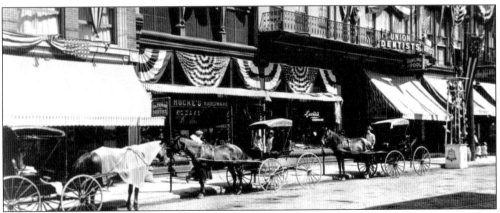

The centennial committee asked all Belleville residents to display the American flag during the celebration, just as Hucke Hardware did in the first block of East Main. The public square was decorated with 40,000 lights and the centennial's official symbol, a gigantic glittering bell, hung in the square throughout the year.

"Centennial March," written by Frank Macke, was the signature song. The Centennial Cadets, a drill team, were ambassadors who performed at many events to promote Belleville's 100th birthday. The centennial committee reported receipts of $18,000, total expenditures of $15,000, and declared a 30 percent rebate to the original centennial fund contributors.

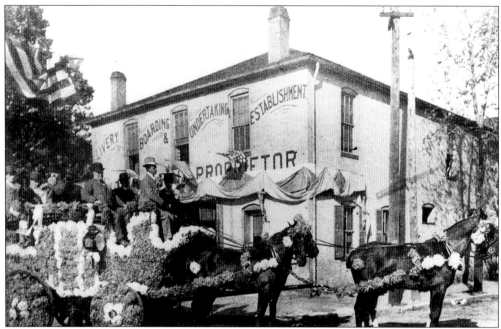

The centennial featured four parades. Ten thousand St. Clair county school children marched in the first, followed on successive evenings by fraternal organizations, industrial representatives, and flower covered autos. This team belonged to L. Wolfort and Company, horse and mule dealers since 1869, with a stable at North High and East "B" Streets. Louis Wolfort expanded into the undertaking business and still maintained an extensive horse and mule buying business throughout western and southern states.

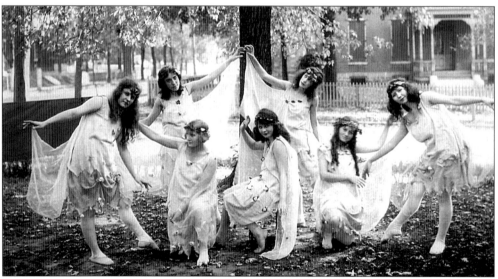

These ladies capture the essence of the spirit of the centennial, gracefully formed and balanced in a wooded setting, frozen in time. Such tableau were artful additions to concerts performed by the Belleville Philharmonic and Liederetafel Chorus during the celebration. The centennial committee filmed the pageant and declared the reels would be placed in containers and not opened until 2014, when they would be shown to descendents of those who participated in the pageant.

Five

PRESERVATION TODAY

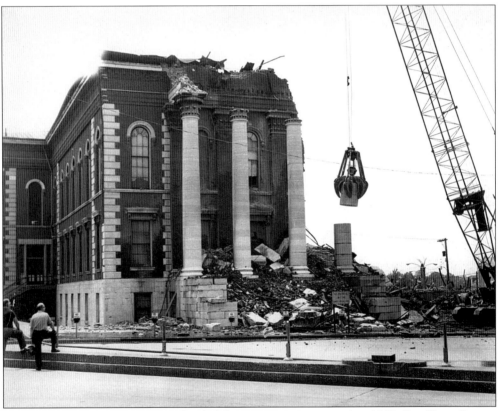

On May 9, 1972, the raucous legal debate over preserving the 1860 St. Clair County Courthouse ended, not with the sound of a judge's gavel, but with the devastating crunch of a wrecking ball. Workers for the contractor hired to build a new courthouse were ordered to begin demolition while a citizens group considered additional legal action to save the building. The Citizens Courthouse Committee realized there was no legal basis for saving the city's historic architecture. The demolition gave birth to the Belleville Historic Preservation Commission and an ordinance authorizing creation of historic districts.

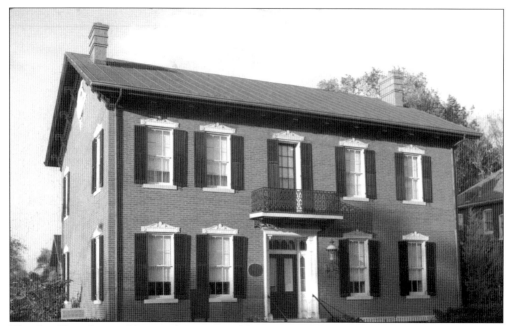

The St. Clair County Historical Society celebrates its golden anniversary December 8, 2005. Founder J. Nick Perrin described the organization in 1930, "The association has the shortest constitution in the world, which is the crying need of all organizations . . . our organization has successfully protected from rapacity the most precious old-time records dating back to 1737 . . . our aim has been to retain and protect what our county has of historic value and we have done it." The society operates this museum at 701 East Washington and the Emma Kunz home at 602 Fulton Street.

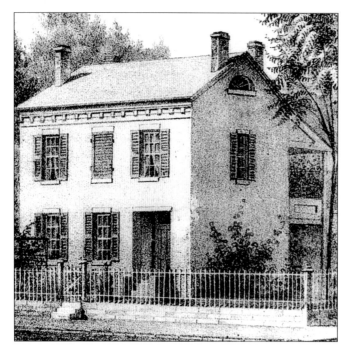

The city of Belleville acquired the Gustave Koerner house at 200 Abend in 2002. Koerner built the home in 1850, lost most of it to a fire in 1854 and rebuilt it in 1855. Koerner fought slavery and supported Abraham Lincoln, serving as a pallbearer at Lincoln's funeral. The St. Clair County Historical Society has launched a campaign to restore Koerner's property to tell the story of an 1833 freedom loving immigrant who played a key role in the Civil War years. Koerner was the quintessential representative of "the German element" in America.

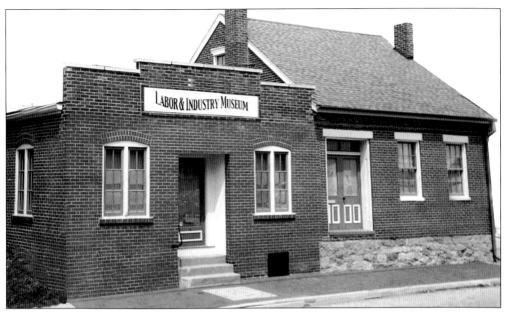

In 1995, preservationists saved the 1837 German street house at 123 North Church, one of the oldest remaining structures in the Original Town of Belleville, then a committee restored the property to house the Labor & Industry Museum in 2002. Exhibits focus on Belleville area work history and the facility stores archives and photographs. Future plans call for exhibition space to show Jumbo, an 1895 Harrison Machine Works steam engine. In its first year, the museum was named "Small Institution of the Year" by the Illinois Association of Museums.

Belleville has hundreds of German American Folk Houses within blocks of the courthouse. The folk house is the enduring physical reminder of the working people who built Belleville in its first 100 years. In 1973, the Department of Interior established a National Register of Historic Places District. The Belleville Historic Preservation Commission has created three local historic districts—Old Belleville, Hexenbuckel, and Oakland—to preserve our oldest neighborhoods. The St. Clair County Historical Society, Belleville Historic Preservation Commission, and Labor & Industry museum hope you have enjoyed our salute to Belleville's first 100 years.

INDEX